NOW THAT'S WHAT I CALL YEOVIL

Bob Osborn

AMBERLEY

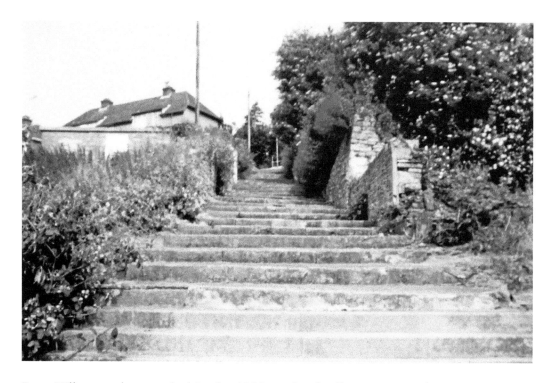

Penn Hill steps photographed in the 1980s and still offering spectacular views across to Summerhouse Hill.

To Carolyn and Alice

First published 2017

Amberley Publishing
The Hill, Stroud, Gloucestershire, GL5 4EP
www.amberley-books.com

Copyright © Bob Osborn, 2017

The right of Bob Osborn to be identified as the Author of this work has been asserted in accordance with the Copyrights, Designs and Patents Act 1988.

ISBN 978 1 4456 7169 7 (print)
ISBN 978 1 4456 7170 3 (ebook)

British Library Cataloguing in Publication Data.
A catalogue record for this book is available from the British Library.

Origination by Amberley Publishing.
Printed in Great Britain.

CONTENTS

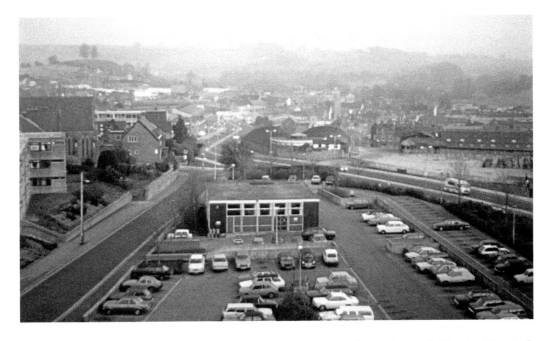

This is an unusual view of Reckleford seen from an upper floor of Yeovil District Hospital. At centre is the hospital staff's social club, demolished many years ago with the space now used as part of the car park, and at top right is the cattle market, which was still in use at the time of this photograph.

INTRODUCTION

There have been many books written about 'old' Yeovil but this book is a little different; it's about 'not so old' Yeovil and concentrates on the town during the latter half of the twentieth century. The idea is to take a nostalgic view of Yeovil during a time that many will remember, perhaps with mixed feelings, but it will hopefully bring back memories of places and events.

The book begins by highlighting some of the many buildings that we pass by, perhaps on an almost daily basis, that tend to disappear without us noticing; for example, you might remember the smell of roasting coffee being wafted across the borough, but did you realise the Cadena building was pulled down in 1983? On the other hand new buildings spring up, so the next part of the book looks at projects such as the new library, the police station and the Tesco store (but omits the seemingly endless supply of new blocks of flats).

We then take a look at some of the many shops you'll probably remember. Larger shops – Woollies, Safeway and Key Markets – and smaller shops such as the W. I. Market, Yeovil Bookshop, Sam McCreary's junk shop (sorry, pre-owned bric-a-brac emporium), City Girl, Bejam and the Wearhouse – the list is almost endless.

Of course, there have always been changes in the town; for example in the 1930s Yeovil was proud of its much-hyped 'new' shopping centre. This small parade of shops was built at the northern end of Princes Street, opposite North Lane, and still exists, but today's modern shopper would really wonder what all the fuss was about. Changes of the past, however, pale into insignificance with the changes Yeovil underwent with new roads and major building projects between the 1960s and 1980s.

During the 1960s Yeovil endured the post-war development of the Glovers Walk shopping centre. The architectural style was a watered-down form of Brutalism and was thought to be energetic and contemporary. The project ran from Vicarage Street to Central Road and from Middle Street as far north as the bus station. To this day many lament the loss of the quirky Middle Street buildings that were replaced by hard, squared edifices of concrete and ceramic tiles and 'lost to progress'.

If the 1960s was a period of upheaval, it wasn't a patch on what the 1980s was to bring. Enter the Quedam Shopping Precinct, designed with a 'village' feel in contrast with the harsh 'concrete jungle' of Glovers Walk. While a few shops and disused factories were lost to Glovers Walk, the Quedam was to claim whole streets. At a stroke Yeovil lost Vicarage Street, Vincent Place, most of Vincent Street and half of Earle Street.

The next chapters look at a range of leisure pursuits enjoyed by Yeovilians, the town's transport systems and, finally, a look at some of the wide-open spaces found within the town as well as outside it.

Bob Osborn
Yeovil, 2017

LOST BUILDINGS

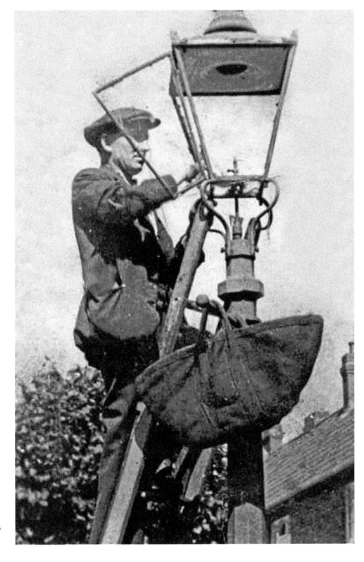

This is a photograph of Fred Butts, Yeovil's last gas lamp lighter, who retired in the 1960s. When I was a young lad, I would often watch with fascination as the lamp lighter came down our street on his bike, precariously balancing his ladder. He would then fiddle with the mantles, clean the glass and light the lamp. But then, without realising it, this part of my childhood had disappeared. It is the same with buildings: we walk past them without taking notice and then one day realise they have gone. This chapter looks at some of the iconic (and less iconic) Yeovil buildings that, apparently, vanished overnight.

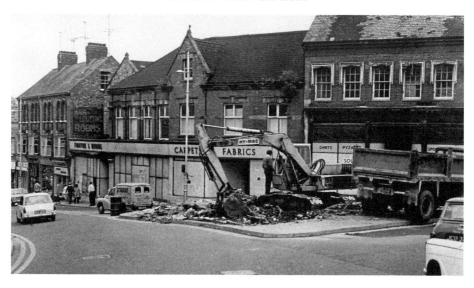

It was never a pleasant experience to descend into this dank, malodorous underground lavatory but, at the time, there was little choice for those 'caught short' at this end of town. Built in the 1930s and surrounded by ornate wrought-iron railings, this facility disappeared in the late 1970s. The buildings on the far left survive today while the remainder, once the home of the Yeovil Co-operative Society, was replaced by the building now occupied by Poundland.

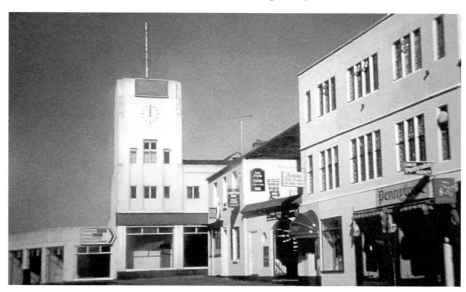

On 25 March 1931 Douglas Seaton's new garage, showrooms and petrol station, with its iconic tower, on the corner of Huish and Clarence Street, were opened in a ceremony by the mayor of Yeovil, Alderman W. Earle Tucker. The new premises were designed by the Yeovil architects Petter & Warren and the main contractors were Bird & Pippard. Douglas Seaton died in Yeovil in the spring of 1973. The Huish premises were sold off and finally demolished in 1991.

In 1865 the Primitive Methodists built this chapel in South Street to accommodate a congregation of 300. In 1932 the chapel ceased to be used as a place of worship and became a glove factory. In 1996, after lying empty for many years, work began to convert the building into an arts centre and retail units. As the alterations began, part of the building collapsed, becoming too unstable for the works to continue, and it was soon completely demolished.

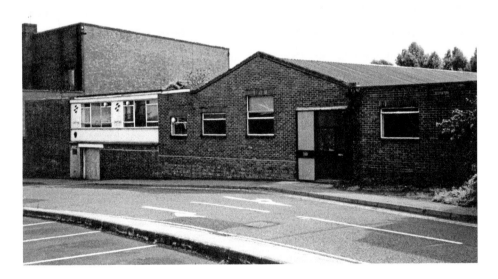

The box factory stood in South Street, almost opposite the Methodist chapel above, and stretched south towards Stars Lane car park. During the 1960s it was known as the Somerset & Dorset Box Factory and then simply S. & D. Cartons. The factory itself was known as the 'Boxall Works'. The box factory was demolished around 2001 and the site is now a car park.

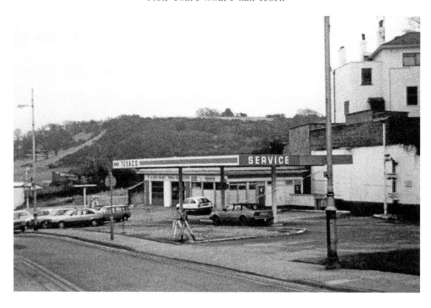

This photograph shows the Texaco petrol and service station in South Street, opposite Bond Street. Later known as the South Street Service Station, it also dealt in used cars. The site remained empty for several years after closure, but the site is now occupied by the blocks of flats called Belmont House and Trinity Court.

A strange-looking 'wonky' building that stood in South Street close to the junction with Addlewell Lane was originally built as the gardener's cottage of Park Street House, which was the home of glove manufacturer William Fooks, the grounds occupying the whole of the eastern corner of the junction. During the early twentieth century this building became Pitman's School of Shorthand and Typing and latterly a hairdresser's premises. It was demolished in 2001.

In 1854 local solicitor James Tally Vining bought land in Church Street for a Sunday school for St John's parish, built in 1856 at a cost of £700. In 1864 the girls' department of Huish National School moved into these schoolrooms and an infants' school also opened. The schools were rebuilt in 1897. In 1984 the ground-floor sections of the schoolrooms were converted into shop premises, the first being opened in November 1984. Note the adjacent half-demolished Central Cinema.

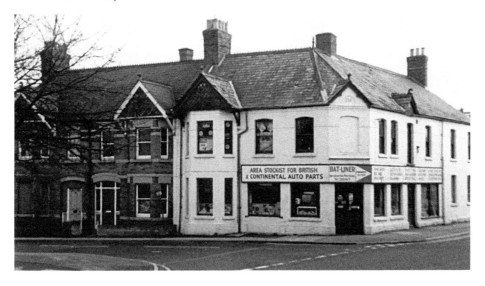

This 1980s photograph was taken from Vincent Street (running off to the right) looking south to Vicarage Street, with Earle Street joining it from the left. The white building on the corner, built in 1888, was famous for being Pearce's sweet factory. By the time of this photograph it was the premises of Bat-Liner auto parts dealer. The building was demolished in the 1980s as part of the Quedam town centre redevelopment project.

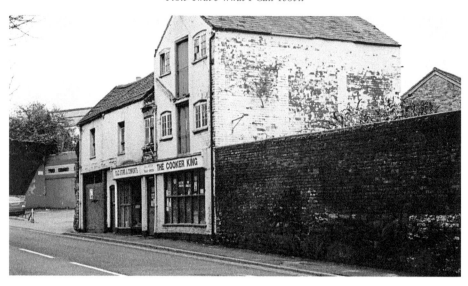

This was the premises of builders' merchant A. D. May, but from 1971 it became famous when the Cooker King, Alan Lovell, began keeping Tara, a one-eyed, rescued lioness at the rear of the property. Alan, with Tara on a lead, would frequently be seen walking around Yeovil and the pair would often attend various local events. Alan had to give up Tara with the introduction of the Dangerous Wild Animals Act, 1976. The building was demolished in 2009.

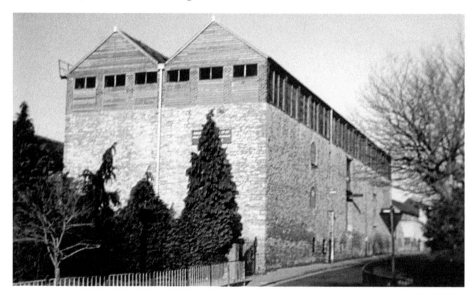

Built around 1828, this is the Eastland Road leather tannery that faces Reckleford. OK, so the building's not exactly gone but the wooden upper floor was removed many years ago. The top floor had louvres all around and spaces between the floorboards to assist in the drying of the skins. However, what has gone, to the everlasting gratitude of generations of Yeovilians, is the obnoxious smell that emanated from the building when it was in use as a tannery.

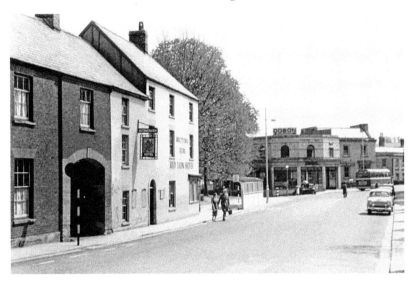

The earliest reference I could find for the Red Lion, Kingston, was 1780 but it had probably been an inn for many years before that. This photograph looks south along Kingston to its junction with Court Ash and Princes Street, marked by the 1930s building of Vincent's car showrooms. Alongside the Red Lion ran Red Lion Lane, which separated the inn from Bide's Gardens, the edge of which is denoted here by the large tree.

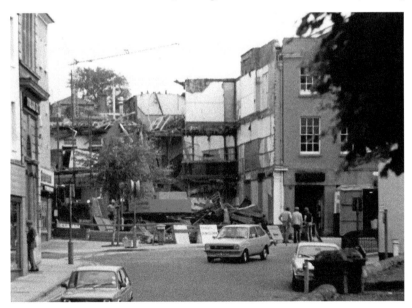

If you ever walked through the borough during the 1970s and early 1980s, you probably remember the wonderful aroma of the Cadena's freshly roasted coffee beans being wafted by fans across the road. There was a winding staircase leading to the upper restaurant with a cashier's cubicle halfway up and the restaurant had an ornate lantern light. Then, one day in 1983, the Cadena was demolished and the tantalising smell of freshly roasting coffee was gone from the borough forever.

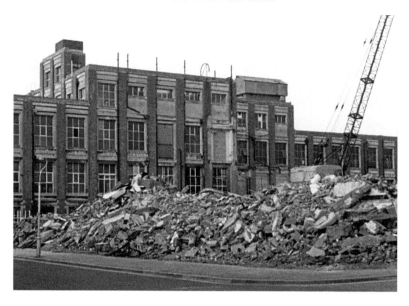

James Shorland Aplin and William Henry Barrett made and sold cheese, cream and butter with their famous St Ivel brand. Their factory was on the eastern side of Newton Road. In 1960 the company was acquired by the Unigate Group, who closed the Yeovil premises in 1976. Much of the factory was demolished and Ivel Court was built on its site. The remaining building, the modernist edifice in concrete and brick seen here in the background, was built in 1931.

It isn't often that a large green shed made of wriggly tin is able to claim to be an iconic part of the townscape. But this was certainly the case with the printing works of Gubbins and Smith on the corner of Newton Road and South Western Terrace. Then one day, like many of the buildings in this part of the book, it was gone and nobody seemed to notice. It was replaced by an eatery, part of Yeovil's leisure complex.

This photograph was taken from the Frederick Place car park in 1983. Left of centre the Labour Club in Vicarage Street was housed in this small 1930s ashlar-faced building with art deco influences. The building was also the local branch office of the Transport & General Workers' Union. The small building to the right was the office premises of Yeovil building firm Pippard & Perry, while the Albion public house is glimpsed on the extreme right. All were demolished shortly after this photograph was taken.

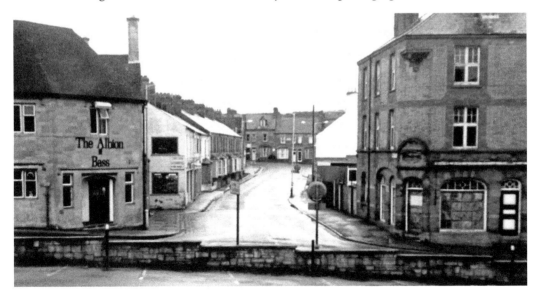

Moving slightly west (with the Albion now seen on the left), this is a view of Vincent Street, built by William Tucker in the 1890s on orchard land. Vincent Street ran north from Vicarage Street, turning 90 degrees west to join Market Street. The terrace of houses on the north side of this section of Vincent Street, called Landsdowne Terrace (seen in the far distance), was built in 1889 and still survives. The rest of Vincent Street was demolished in 1983.

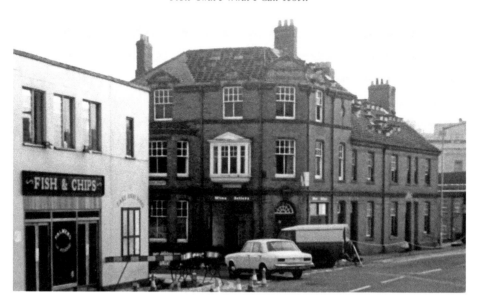

This photograph was taken from Market Street (which runs off to the right) and shows the junction with the western end of Vincent Street. On the left, Palmer's fish and chip shop and restaurant remains today but the red-brick buildings were all demolished in 1983 and today the site is the Market Street roundabout. At the time of this photograph the three-storey building in the centre was 'Wine Sellers', but the roof tiles are being removed in advance of the demolition.

Taken in 1983 from Park Street, this photograph looks down to the site of the former W. J. & E. G. Ricketts & Co. glove factory in Addlewell Lane. The factory closed and the site was cleared for the Central Acre development. The south-western side of Belmont Street had also been demolished. In due course this part of Addlewell Lane would be realigned and the new road, between Summerhouse Terrace and the remains of Park Street, would become Taunusstein Way.

As seen in the previous photograph, the western side of Belmont Street (not to be confused with Belmont, a continuation of Park Street towards Brunswick Street) was demolished in 1983 for the building of Central Acre (just glimpsed on the extreme right here). In 1987 houses on the eastern side of Belmont Street were demolished for the line of the new road, Taunusstein Way.

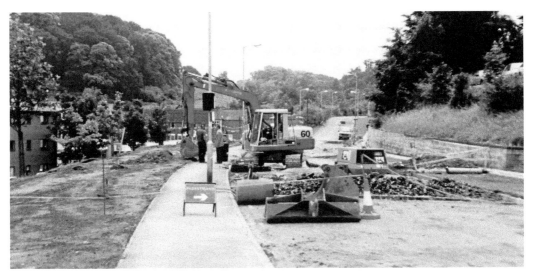

Most of the buildings in Park Street, almost all houses, were demolished in the 1960s. The road itself was later realigned to form Taunusstein Way. Taunusstein is an umbrella name for a group of ten small German villages that were merged together in 1972. Yeovil twinned with Taunusstein in 1987. This photograph, taken some twenty years later, shows the tiny part of the northern end of Park Street being converted into a small car park off South Street, opposite Bond Street.

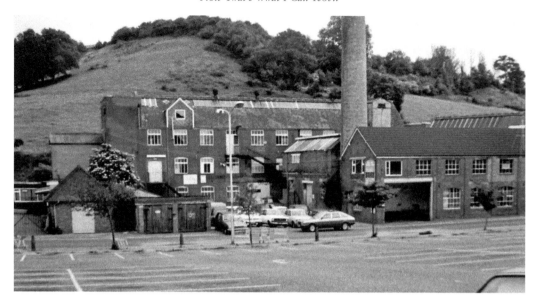

Photographed here in 1986, with the slopes of Summerhouse Hill as a backdrop, this complex was known as the Foundry House Trading Estate. The large building was the premises of Blake & Fox, who were leather dressers and glove manufacturers throughout the first half of the twentieth century, with this large factory and dressing yard in Summerhouse Terrace. By the 1970s the factory and outbuildings had been split into many small light industrial units. The site is now housing of Tanyard Way.

Again seen in 1986, this was an extension of the Blake & Fox factory that ran alongside Summerhouse Terrace, facing today's Stars Lane car park. Also split into several small trading units, this long building was used by Riders of Yeovil for motorbike sales, and on the first floor was a music and musical instrument outlet called the Music Mill in the early 1980s.

William and Edward Ricketts came from a glove manufacturing family and began their own company, W. G. & E. G. Ricketts Ltd, in the 1920s. As well as this glove factory in Addlewell Lane, the brothers also owned a tannery in Stars Lane, although this was destroyed by fire in 1931. The company closed in 1980 and in 1983, the date of this photograph, the glove factory was demolished and the Central Acre development was built on the site.

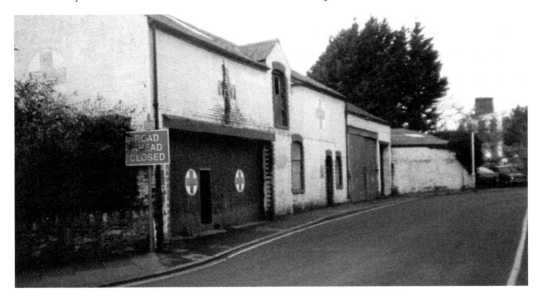

This 1980s photograph was taken from West Hendford and shows the old ambulance station at the southern end of Salthouse Lane. The ambulance station was Yeovil's first, but it was later used by the St John Ambulance. The lane was named for a meat-salting house established at the northern end by at least 1733. The site of the ambulance station is now a block of flats.

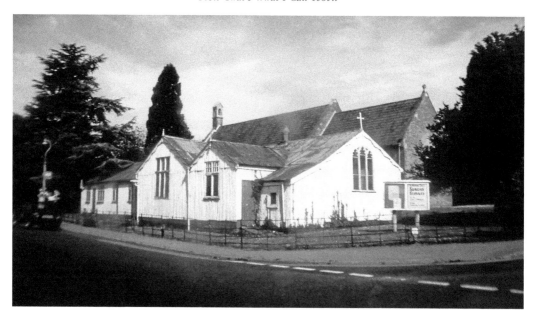

St Andrew's Church (seen here in the background) in Preston Grove was built in 1934 and the white building was its church hall. The 'tin hut' was used by generations of Yeovilians as their playschool, Sunday school, or where they attended a range of activities from Scouts and Guides to ballet classes. The hut even made an appearance in the 1986 Hywel Bennett film *Frankie and Johnnie*. It now has a brick-built replacement.

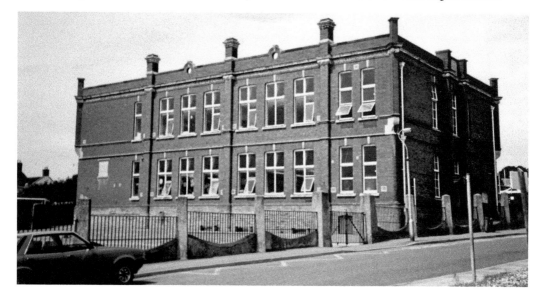

Huish County Junior School was built on the north-west corner of Salthouse Lane at some time before 1927, but the rest of the land to the west of Salthouse Lane, originally the field called Croft, was to remain as an open space called the Fairfield until the 1970s, when the Wellington Flats development was constructed. Huish County Junior School was demolished in 1991 and the Tesco petrol station now occupies the site.

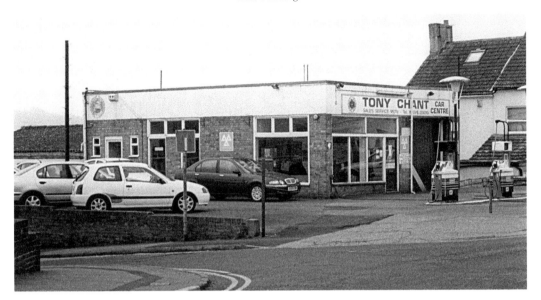

Tony Chant's petrol station and used car sales, seen here around 1985, occupied a corner site in Huish at the junction with Richmond Road. The filling station was serviced by an attendant who was notified of customers by an electric cable across the forecourt that rang a bell in the office when a car ran over it – and every little boy would jump on the cable when passing. The site is now a large block of flats.

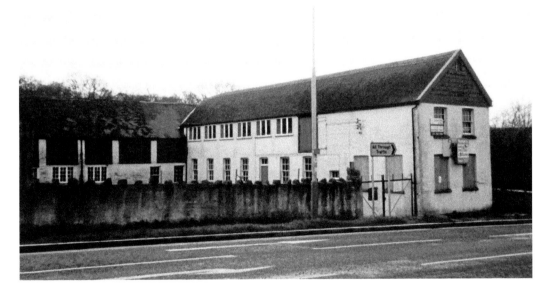

In 1952 Lionel Nichols established a company of leather dressers and glove manufacturers with its main production premises on the corner of Hendford and Brunswick Street, close to the present police station roundabout. During the 1980s production moved briefly to Milborne Port, then returned to Yeovil, setting up in the Nautilus Works off Reckleford around 1990. Part of the original buildings became the Hendford public house, now known as Coopers Mill.

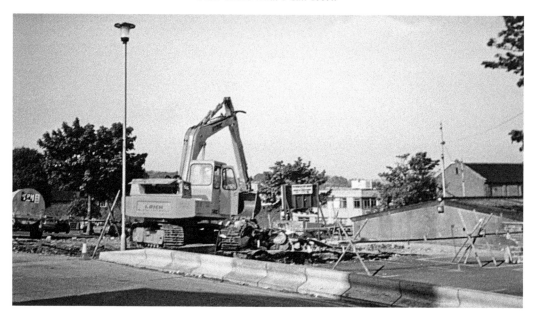

Petters Way was constructed in 1936 and its northern end, adjoining South Street, was home to Yeovil's weekly Friday market for many years, being used as a car park for the remainder of the week. Between this front section and the main car park was a toilet block and sundry storage sheds. This mid-1980s photograph shows the demolition of the toilets and sheds to clear the site for today's Petters House.

The North Lane abattoir was one of several Victorian slaughterhouses in Yeovil town centre. There was another just around the corner in Vicarage Street and a third behind houses on the north side of Middle Street, opposite Union Street. The North Lane abattoir, opposite the entrance to the North Lane car park, was part of the animal market now occupied by Court Ash car park. Used for other purposes after the Second World War, the site is now flats.

In 1824 Thomas Cave established a brewery in Clarence Street (actually in the garden behind his house in Princes Street) – seen here in the 1980s. By 1854 Joseph Brutton was a partner with Thomas Cave, taking sole ownership after Cave's death. Mitchell, Toms & Co. Ltd of Chard took over Brutton's in 1937 and it was taken over again by Charrington & Co. Ltd, London, in 1960. The Yeovil Brewery ceased to brew in 1965. The site is now flats.

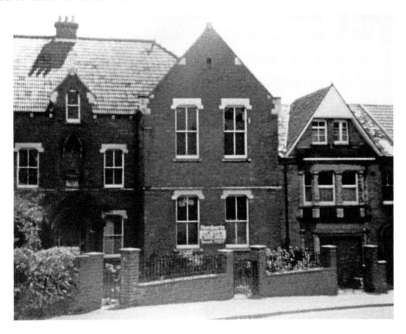

During the late 1970s and early 1980s it was a familiar sight to see the nuns of the Sisters of St Gildas convent walking around Yeovil. The sisters envisaged their presence here as a missionary one, education being a priority, and in 1908 a private school, run by the nuns, was established in the convent. The convent closed and was demolished in 1984. A sheltered housing scheme, Crofton Court, was built on the site in 1988.

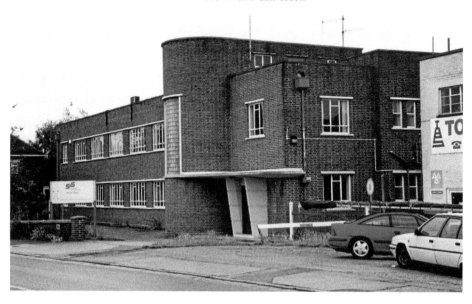

Often under-appreciated, this art deco-inspired light industrial unit was built in West Hendford during the 1960s for the electricity board. Built in brick, the front elevation had an off-centre projection housing the stairwell, lit by a glass block wall typical of the style. The entrance, to the side of the projection, had a reinforced concrete canopy on sloping supports. Later the Yeovil depot of Scottish and Southern Energy Plc, the building was empty by 2008 and demolished in 2010.

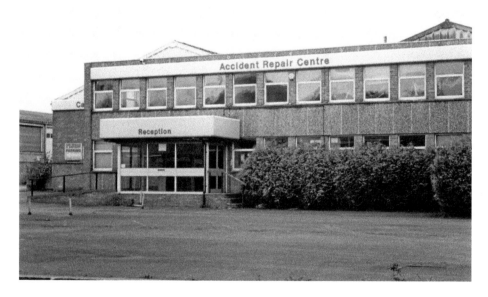

Another building in West Hendford that has been replaced by blocks of flats is Douglas Seaton's Accident Repair Centre. To be honest the 1960s building was nothing special to look at, being on the edge of a light industrial zone abutting a residential area, but it was passed on a daily basis by hundreds of workers as they made their way to Westlands.

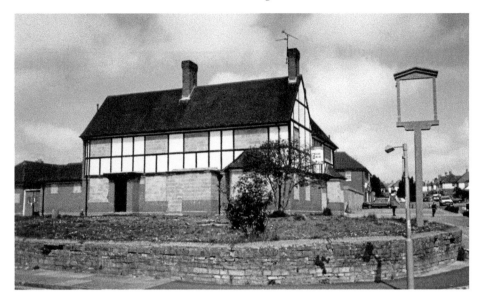

The Westfield Hotel opened in January 1938 and was a purpose-built establishment catering for the large housing estates built in the interwar period in the area of Coronation Avenue, Stiby Road and Westfield Road. I have included it here as representative of the large number of pubs lost to Yeovil during the latter half of the twentieth century. The Westfield Hotel was demolished in September 1996 and flats, Raglan Terrace, were built on the site in 1998.

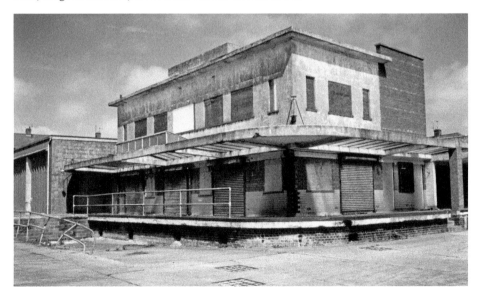

This photograph is of the dairy owned and operated by the Yeovil & District Co-operative Society in Grass Royal. The society was registered in June 1889, when fifty members were enrolled to the new society. By 1939 the society had twelve outlets plus this dairy, a bakery, a coal wharf in Hendford Station yard and a ladies hairdressing salon. The dairy, seen here in the late 1980s, is now the site of Royal Close.

S. & G. Cooper was a small glove manufacturing company of the early to mid-twentieth century and operated at the Highfield Works in Highfield Road, seen here in a photograph of the mid-1980s. By this time the Highfield Works had been converted to a small trading estate of retail and light industrial units. The site was completely demolished in the early 2000s and is currently wasteland.

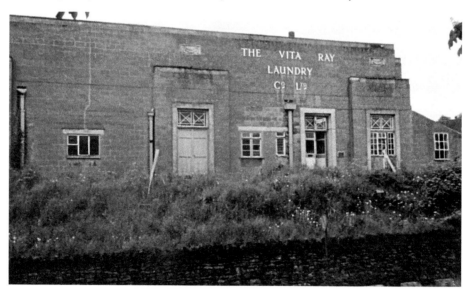

As you approached Yeovil from Sherborne, one of the first buildings you would have encountered was the Vita Ray Laundry, sited on the lower slopes of Wyndham Hill adjacent to the Sherborne Road close to the junction with Lyde Road. The laundry opened in September 1930 and operated until the late 1970s. It was demolished in the 1980s and the site is now occupied by the houses of Wyndham View.

Houndstone Camp was a permanent camp used extensively by the British Army, although in 1942 the British garrisons moved out of the Yeovil army camps in order to make way for incoming Americans. Houndstone became home to several American units. Today it has all but disappeared, now being the site of trading estates and the home ground of Yeovil Town Football Club, although several roads, such as Barracks Close, Warrior Avenue and Guard Avenue, recall the earlier camp.

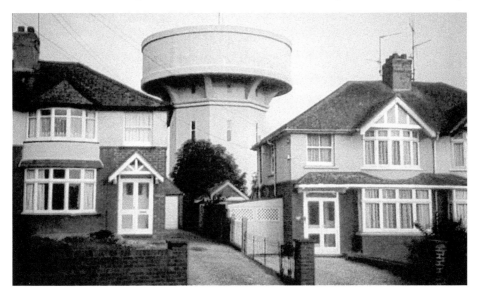

The water tower at the end of Ashford Grove, the highest point in Yeovil, was built in the 1930s to serve the new homes that were being built in the Glenthorne Avenue area. It was a clear skyline landmark visible, for instance, from the A303 above West Camel, 5 miles to the north, or from the Corton Denham Ridge, a similar distance to the north-east. This water tank was demolished in 2005.

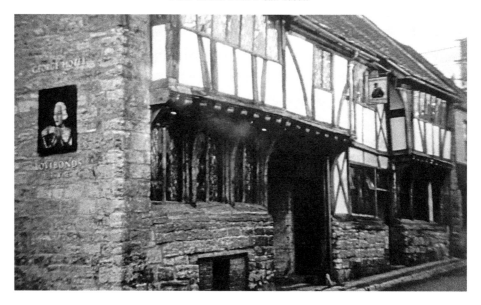

The George Inn, Middle Street, began life as a private dwelling, built during the 1400s. From 1478 it was owned (among other licensed premises) by the Trustees of Woborn's Almshouse, who continued to own it until 1920, with the rent of the building providing a regular income for the almshouse. The George Inn, the last remaining secular medieval building in Yeovil, was demolished for road widening in 1962. Despite its destruction, the road was pedestrianised within a decade.

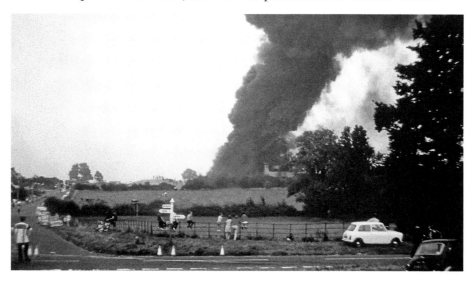

The Larkhill Rubber Co.'s soling factory was built in 1961 off Larkhill Road on the north side of Yeovil, just on the outskirts. It was owned by Clarks, Europe's largest shoemakers. The Larkhill factory produced rubber and PVC soling for Clarks' footwear. In August 1970 children playing in the grounds of the factory set fire to wooden pallets and drums of chemicals. The fire quickly spread and got out of control but fortunately there were no injuries.

Yeovil Town Football Club's home ground at Huish, just west of the town centre, was beloved by a league of loyal supporters. The pitch itself was famous for having an 8-foot sideline-to-sideline slope. The main entrance was in Huish and entered the ground under the main stand, which, by the time of this photograph, was boarded up. The club moved to a new stadium in 1990 and the old Huish ground was demolished in 1991.

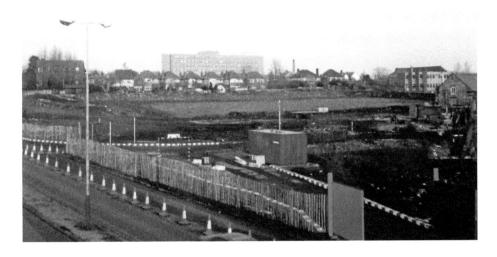

This, a very sad sight for many a loyal Yeovil Town fan, is probably the last ever photograph of the famous sloping pitch at Yeovil Town Football Club's Huish ground. It was taken from the footbridge over the Queensway dual carriageway and the ground's western end was consequently known as the Queensway End. The eastern end was called the Brewery End since it backed onto the old Brutton's Brewery. The former ground is now the site of the Tesco superstore.

REDEVELOPMENT

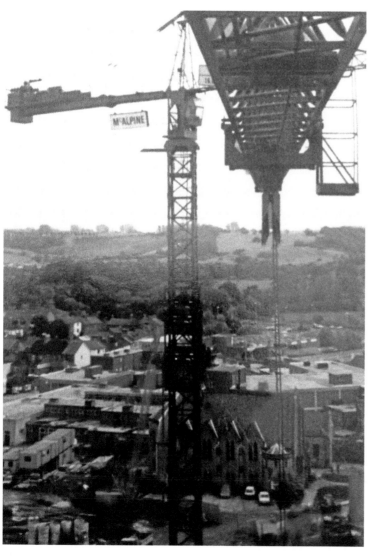

In recent years Yeovil has seen major disruptions due to what seems to be a never-ending series of major new road schemes. During the latter half of the twentieth century the significant disruptions were caused by sweeping new town centre building schemes, symbolised by this dramatic photograph taken from the cab of one of the tower cranes that dominated Yeovil's skyline for months at a time.

While the previous chapter saw the disappearance of many iconic buildings, several of which were replaced by residential developments, this chapter looks at some of the smaller non-housing new building schemes that sprang up in Yeovil.

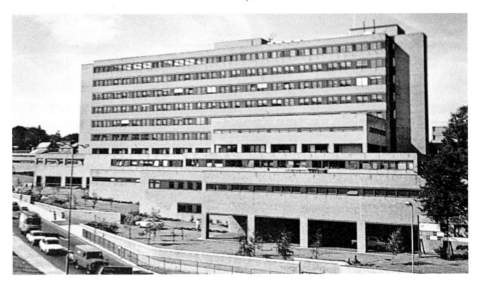

It was a perennial problem that affected all of Yeovil's previous hospitals – the town was growing faster than the facilities of the hospital could cope with. By the 1960s a new district hospital was planned that would not only replace the old general hospital, but provide a higher standard of care to a much larger population, Yeovil and the surrounding district. Building began on today's hospital in 1968 and the first patients were admitted in February 1973.

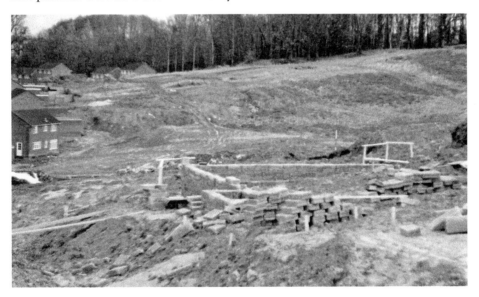

In 1970 residential estates began to be built on the western side of Yeovil, running along the north side of the newly constructed Lysander Road. The first roads and houses to be built were Maple Drive and Pine Tree Avenue. In 1976 houses in Cypress Drive were built, followed by Russet Way and Plantagenet Chase in 1978. This photograph of early 1978 shows the site cleared and ready for the groundworks of Plantagenet Chase.

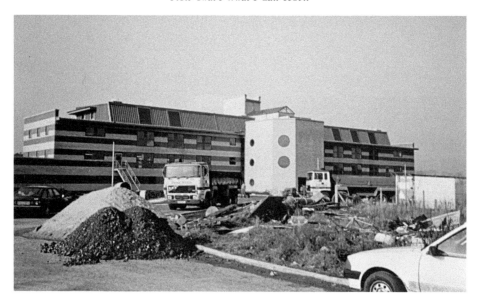

During the late 1970s and early 1980s Yeovil District Council (it became South Somerset District Council in April 1985) had several small offices within the town. A study was undertaken to rationalise the authority's office accommodation and the decision was taken to construct a new headquarters office at Brympton Way on the western outskirts of the town. The new offices were constructed during 1983–84.

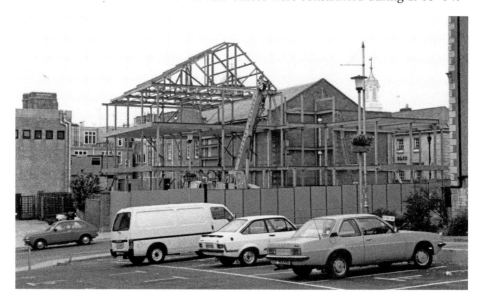

When new municipal buildings opened in King George Street in the early 1920s, the Borough Library was housed at the southern end of the new building. Space was always at a premium and the old library was replaced by a new, purpose-built library in 1986 on the south-east corner of King George Street. This photograph shows the steel frame of the new building being erected on the site of the children's library and the council's staff car park.

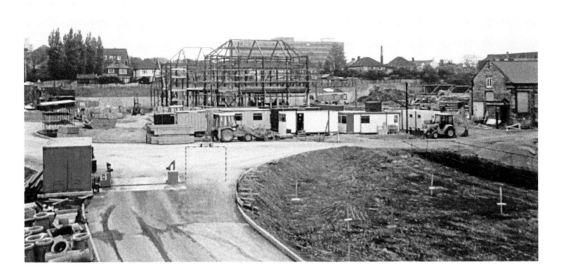

When the football ground at Huish was demolished in 1991, the site was cleared and the new Tesco superstore was constructed at the western half of the site, with a large car park occupying the eastern half. The whole was accessed via Queensway with eastern Huish blocked at Clarence Street and renamed Queensway Place. This photograph shows the steel frame of the new store being erected and in the foreground the site is cleared for the new petrol station.

Yeovil's first police station was in the Town House in Union Street from 1849, until moving to the law courts building in Petters Way during 1936. The new police station in Horsey Lane was built in the late 1970s, opening in 1978. The facility is scheduled to close in 2017 and relocate to the Reckleford fire station. This 1989 photograph, taken from Brunswick Street, shows the police station on the right and the Hendford pub (now Coopers Mill) on the left.

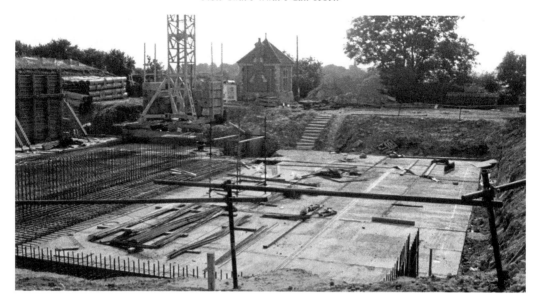

As Yeovil grew dramatically in the nineteenth century, supplying the town with water became a constant problem. Traditionally the town had relied on numerous wells for its water supply, but as the town expanded and its population grew, these proved inadequate and summer droughts became a regular feature. In 1897 a huge underground reservoir was constructed on the top of Summerhouse Hill with a capacity of over 1 million gallons. The reservoir was enlarged, seen here during the 1980s.

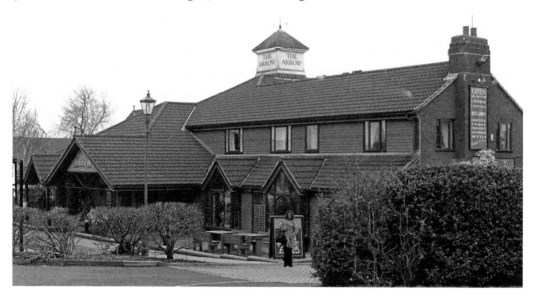

During the latter half of the twentieth century Yeovil, in common with most towns, saw the closure of many of its public houses. However, three new pubs were to open. The Great Lyde was converted from Great Lyde farmhouse to cater for the new estates around Cavalier Way. Two new estate pubs were built; the Arrow, shown here, serving the Abbey Manor estate and the Airfield Tavern serving the new housing based around Bluebell Road.

One of Yeovil's last major building projects of the twentieth century was the Yeo Leisure Park, lying at the foot of Summerhouse Hill and built on the site of the old Yeovil Town railway station. Comprising a ten-screen cinema, a bowling centre, fitness centre, two restaurants and retail outlets, the scheme provided the town with a modern leisure complex.

Yeovil Town Football Club now play their home matches at their new ground, Huish Park Stadium, built in 1990 on the outskirts of the town and on the site of the northern part of Houndstone Army Camp. The new ground is named after the club's former home in Huish, which was famous for the notorious sloping pitch. The stadium complex also contains conference and banqueting facilities.

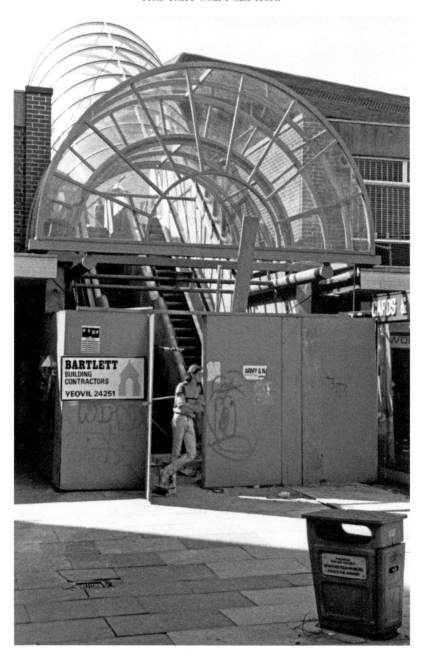

The 1950s and 1960s were a period of dramatic change in post-war British architecture. Indeed, during this period hardly an English town escaped dual carriageways and massive town centre redevelopment, usually in concrete and prefab tiles – Yeovil was no exception.

The 1960s saw the creation of the Glovers Walk project and during the 1980s the Quedam Shopping Centre project was completed. This photograph is symbolic in that it shows the construction of the escalators that joined the lower-level Glovers Walk with the upper level of the Quedam Centre.

Yeovil's Glovers Walk project was designed and built during the 1960s at the height of the Brutalist architectural period, although it never quite achieved the true harshness of Brutalism. Thought to be uncompromisingly modern at the time, Glovers Walk aroused extremes of emotion and debate, which only appears to escalate today. Some regarded Yeovil's Glovers Walk buildings as monstrous soulless structures of concrete, steel and glass, whereas others saw the genre as a logical progression, having its own grace and balance.

Building the Quedam Shopping Precinct during the early 1980s was the largest construction project ever to be undertaken in Yeovil. The architecture was an attempt to bring a 'village' feel to the town centre's shopping experience, in contrast to the Glovers' Walk project of the 1960s. The Quedam swept away Vicarage Street almost completely, as well as most of Earle Street, Vincent Street and Vincent Place. The view from Silver Street, Market Street and the Triangle were forever changed.

While most of us went about our lives with, perhaps, a grumble about the inconvenience of a giant building site in the town centre or bemoaning the loss of the above-mentioned streets, at least a few people had the foresight to put their cameras to good use during the construction of the new shopping centres. Their photographic work brings this next section of the book to life and will bring back many memories of trying to work or shop close to a giant building site.

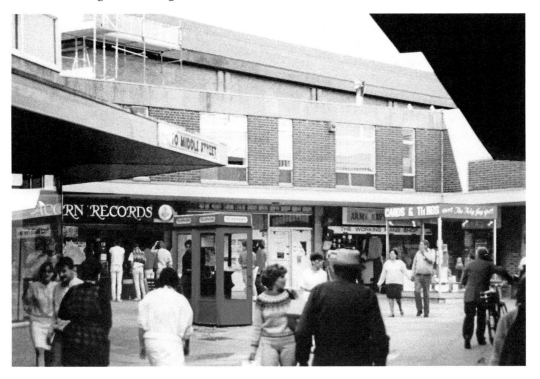

This photograph shows a busy day in the Glovers Walk central piazza during the early 1970s. The later escalators shown on the facing page were constructed behind the telephone kiosk by demolishing the central shop. The Army & Navy stores were soon to disappear, as was the freestanding display unit, but Acorn Records was in this location until moving relatively recently.

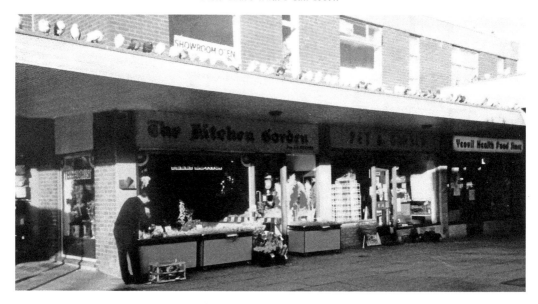

For some reason, despite efforts to discourage them, the pigeons always congregated in Glovers Walk more than anywhere else in town. This late 1960s photograph, taken closer to the bus station (accessed off photo to the right), shows shops that are long gone: The Kitchen Garden, Pet & Garden and Yeovil Health Food Store. All these premises seem to have had a high turnover of occupiers through the years.

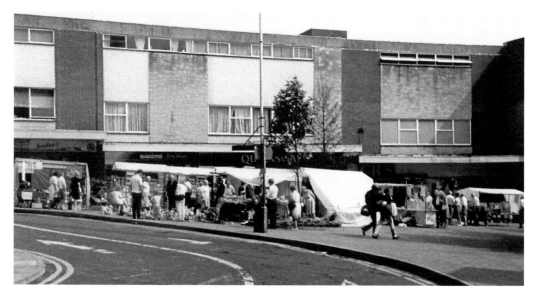

The weekly market held in the Petters Way car park, close to South Street, was moved to the newly pedestrianised Lower Middle Street during the 1980s. This photograph looks across the Triangle from the junction of South Street and Stars Lane. The buildings here were the western end of the Glovers Walk project that ran from Vicarage Street (just off photo to the left) all the way to Central Road. The buildings seen here replaced the Coronation Hotel & Vaults.

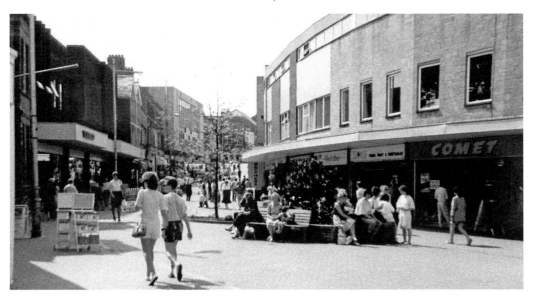

Looking west along Lower Middle Street towards the Triangle (glimpsed in the background behind the tree), the parade of shops on the right was the continuation of the Glovers Walk project as it curved around towards Central Road. Stokes' fruit & veg shop is long gone, as is the Comet outlet. Note that at this time Tesco occupied the premises currently used by Wilko.

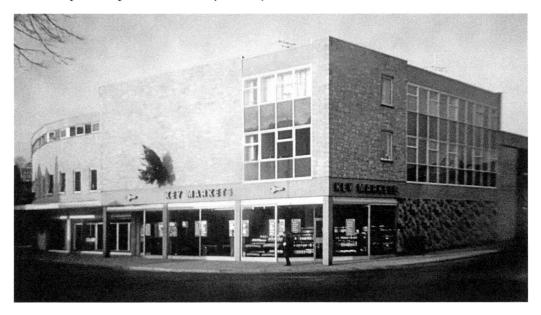

This large cube of a building was the architect's visual 'stop' at the end of the run of shops forming the Glovers Walk parade along Lower Middle Street. During the 1970s it was occupied by Key Markets (before they moved directly across the road into the new Key Markets House, today occupied by Premier Inn and Beefeater). The next occupier was Haskins furniture store and today it is the William Dampier Weatherspoon's pub.

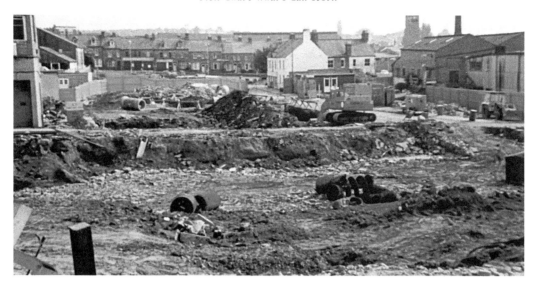

This two-page spread illustrates some of the disruption caused by the Quedam project during the 1980s. This photograph was taken from Frederick Place and looks north towards the remains of Vincent Street in the distance. At centre is the site of what had been the Albion Inn and at centre left edge is glimpsed the old Labour Club about to be demolished. The deep excavation running across the centre of this photograph is where Vicarage Street used to be.

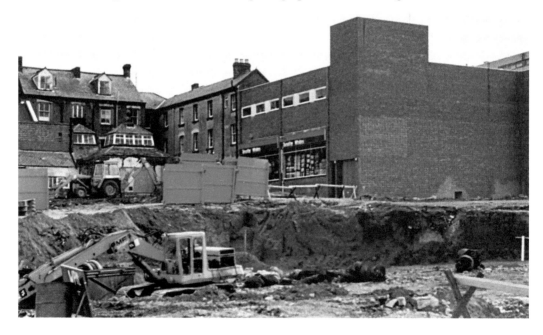

This is the complete opposite of the previous photograph and looks from the site of the Albion Inn to Frederick Place, left of centre. The newish red-brick building on the right is the back of the Timothy White's premises. The 3.5-metre- (12-foot-) deep excavation running across the lower half of this photograph is close to where Vicarage Street once ran. The top of this vast hole approximately marks the original road level.

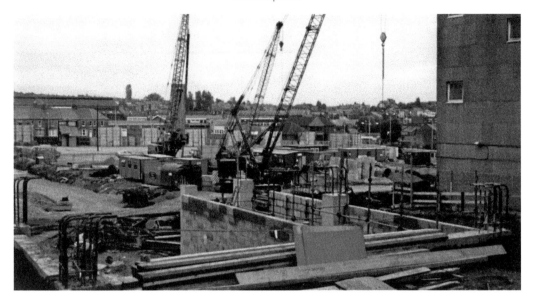

Taken a few months later, this is almost the same view as above. Here the remaining houses of Vincent Place are seen in the background on the left and just to the right of the right-hand crane is glimpsed the new Labour Club. By this time the site was becoming more organised with site offices and building materials nestled between the cranes. In the foreground, construction of the new buildings is well underway.

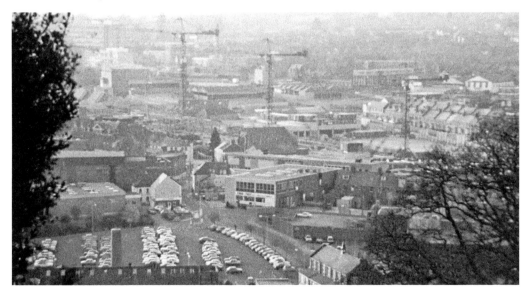

Taken on a hazy day from the slopes of Summerhouse Hill, this photograph illustrates just how large the Quedam project was, with three tower cranes dominating the town centre. In the foreground is Stars Lane car park with Foundry House at bottom right. At centre is the Vicarage Street Methodist Church and the remaining houses of Vincent Street are at centre right. Beyond the cranes are the sheds of the animal market with the old Odeon cinema left of the cranes.

The four photographs of this two-page spread all show different stages of the Quedam project as it affected the eastern end of Vicarage Street. This first photograph shows Vicarage Street winding around the car park before the demolition works began. At left is the Albion Inn and the old Army & Navy Stores at centre, both of which flanked Vincent Street. On the right is the building that had been the premises of builders' merchants Neal & Williams.

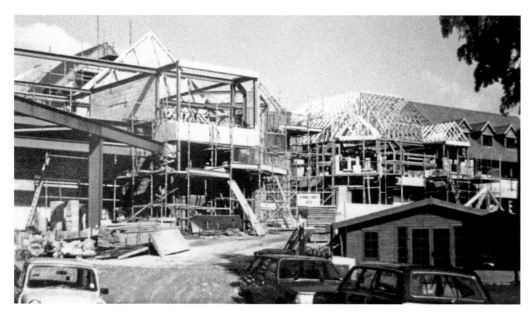

This photograph was taken almost from the same spot as the previous, but several months later. Construction is well underway and it is possible to discern the shapes of today's buildings from the mass of steelwork and concrete block work. On the left is the building that now houses, among others, the Laura Ashley outlet, while on the right the large partially roofed building today houses, again among others, Iceland.

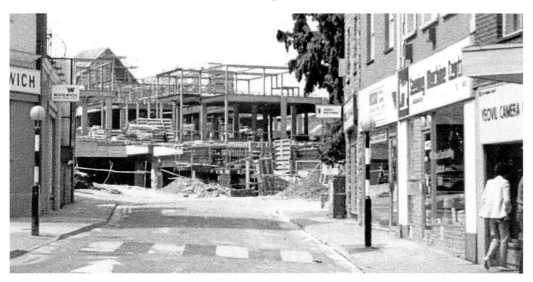

Moving slightly back towards the Triangle, this view makes it difficult to visualise the earlier streetscape that was Vicarage Street. Notice, on the extreme left, the old Belben's Emporium building is now occupied by the Woolwich Building Society and on the right you may remember the Abbey National Building Society, the Sewing Machine Centre and the Yeovil Camera Centre – all now long since disappeared.

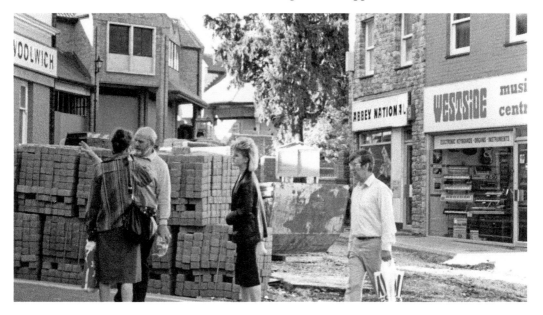

The scene now appears close to how we see it today. The stacks of bricks on the left are in readiness to pave and pedestrianise what little remained of this eastern end of Vicarage Street. It also seem quite remarkable that the tree, featured in all four of these photographs and at the entrance to the Vicarage Street Methodist church, survived the construction works. The Woolwich and Abbey National Building Societies remain and the Westside Music Centre now occupies the previously vacant shop premises.

The four photographs of this two-page spread, all taken from St John's churchyard, show different stages of the Quedam project as it affected the western end of Vicarage Street. This first image is before the demolition works began and shows the side of the Kings Arms on the left and Vicarage Street on the right. Almost all the buildings in the centre were demolished and on the right, as this sequence of photographs will show, the three-storey buildings visually became two-storey buildings.

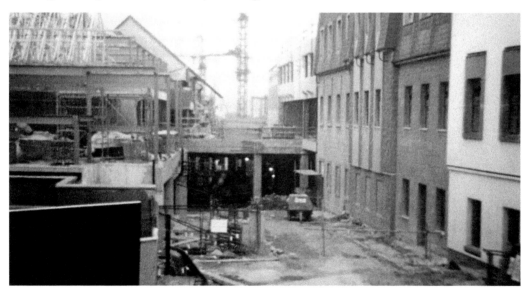

Taken several months later and the construction of the Quedam Shopping Centre is well under way. On the left is the wall of the Kings Arms and at right are the three-storey buildings. At centre bottom is what had been Vicarage Street and in the centre, seen just below the crane, is the reinforced concrete platform supported on reinforced concrete columns, which will become today's walkway level of Vicarage Walk.

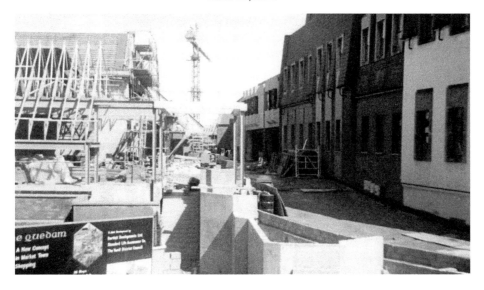

In this photograph the walkway level of Vicarage Walk has now been extended all the way past the existing buildings to finally slope down to meet Silver Street. The effect of the new walkway is that the three-storey buildings on the right now appear to be two-storey buildings. On the left work continues on the new shop premises and in the foreground the complex wall structure (that you always thought was made of natural stone) reveals its reinforced concrete core.

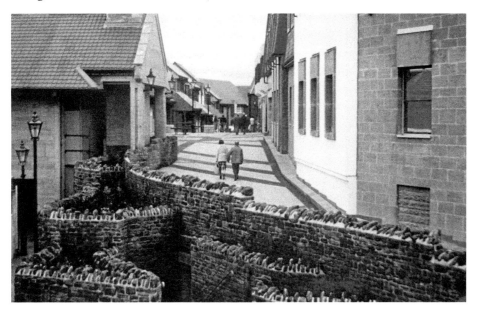

The Quedam Shopping Centre finally opens to the public – and the natural stone wall with the reinforced concrete core in the foreground is completed. The final photograph of this spread of four shows the dramatic difference that a few months of intensive building work can make to a streetscape. Compared with the first photograph, the scene is all but unrecogniseable.

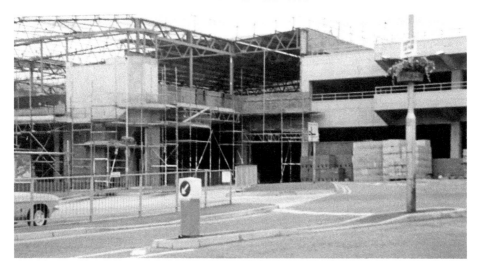

Moving now to Central Road, this photograph shows the construction of the multistorey car park on the northern perimeter of the Quedam project. The entrance to the car park is in the centre and on the right the car park structure is as we see it today. On the left is the exit from the bus station, behind which the steelwork frame has been erected for the large building originally occupied by the Safeway supermarket and latterly by BHS.

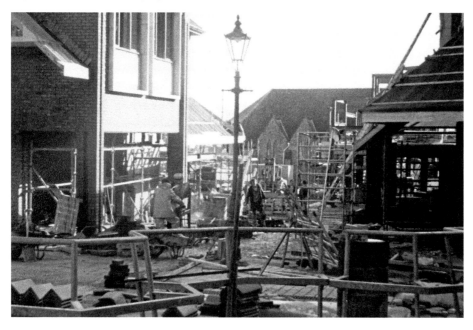

By the time this photograph (which should be subtitled 'Order out of Chaos') was taken in the early spring of 1984 all major building work was reaching completion. There then followed months of work 'finishing off' interiors of the buildings; electricians, plumbers, plasterers, decorators and so on. The outside, as seen here, was just as busy with the installation of street furniture, paving and planting areas.

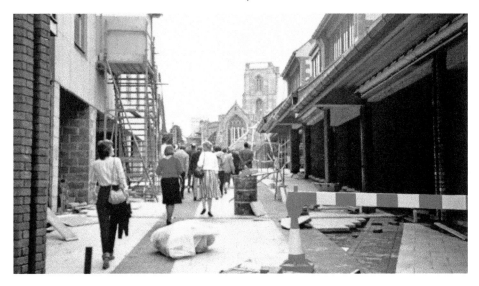

By September 1984 the Quedam Shopping Centre project was well on its way to completion. This was a time of putting the 'finishing touches' on the project prior to handover and traders eventually taking occupation. This photograph shows a group of Yeovil District Councillors (it wouldn't be renamed South Somerset District Council until the following year) being given a tour of the project.

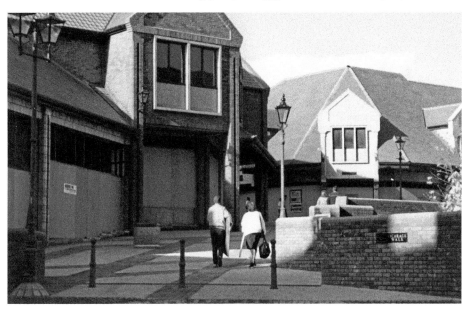

In the space of a few weeks the public were allowed access. Of course, at this time no shops were occupied but at least it was a chance to have a look around Yeovil's new 'village feel' shopping centre. This photograph was taken from what was effectively the last vestige of Vicarage Street close to the Methodist church. The building left of centre would soon be occupied by a Laura Ashley outlet while the building on the right would become Café Royale.

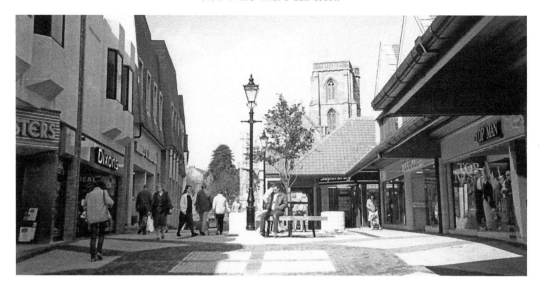

This photograph was taken during April 1986 and shows the now fully occupied shops at the western end of Vicarage Walk – one storey above the ghost of Vicarage Street. On the left, Fosters and Dixons are long gone but Marks & Spencer remains today. On the right, Superdrug moved to the Borough, Mothercare left Yeovil and Top Man remains, although these buildings have recently been remodelled into glazed, stark-white 'boxes' and moving towards a more trendy twenty-first century style of architecture.

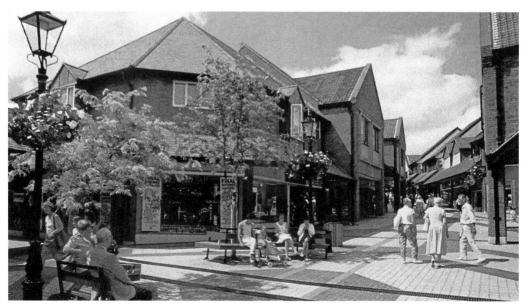

This view, taken from a late 1980s postcard, shows Ivel Square at the eastern end of the Quedam. By this time the new shopping centre was complete and all shops were occupied. The view is almost identical today, some thirty years later. Many shop premises have frequently changed occupiers but one or two, like the Laura Ashley outlet left of centre, have remained throughout.

SHOPPING

This photograph, taken in the mid-1970s, shows Middle Street from the then-newish building that today houses Marks & Spencer. Dunn & Co, gents' outfitters, seen on the extreme right was on the corner of Union Street. At top left the Finefare supermarket occupies what had been Yeovil's first supermarket, Elmo. It was recently, for many years, Primark.

When I first moved to Yeovil in 1973, it seemed that every other shop was a shoe shop. During the 1980s there seemed to be a plethora of building societies and later came a rise in mobile phone outlets. Today, of course, with the rise of internet shopping and the increasing rents of town centre premises, Yeovil, as many towns across the country, is seeing an ever-increasing number of vacant shop premises.

The thing with shops is that they often seem to change occupiers with amazing regularity and for many people this will probably be the most nostalgic chapter in this book. It will also hopefully demonstrate how quickly the shopping experience in the town has changed. I have attempted to indicate, for many of the shops, their previous occupiers, occupiers at the time of the photograph and most recent occupiers.

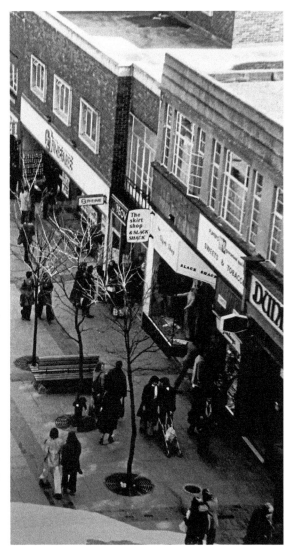

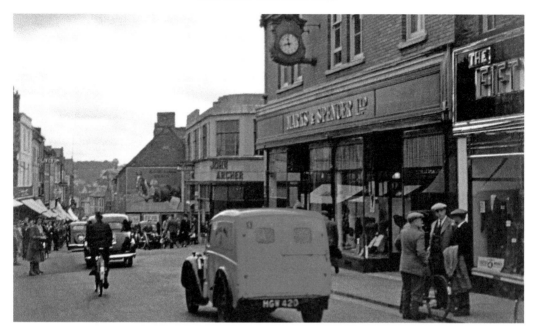

The oldest photograph in this book, from around 1956, portrays a completely different Yeovil from today. On the left the George Inn and Chubb's bakery project into Middle Street, suggesting the original line of the medieval street. John Archer's was a tobacconist on the corner of Union Street and Marks & Spencer occupy the old post office building, now WHSmith. On the far right the Fifty Shilling Tailor offered 'cheap' or 'reasonable' suits, according to the salesman's choice of language.

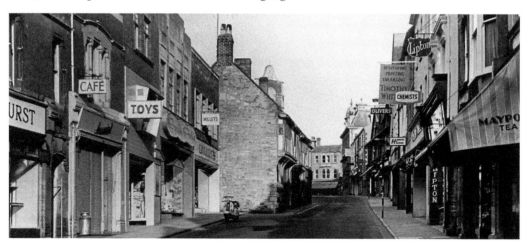

An evocative photograph from the other side of the George Inn, Middle Street, looking back to the Borough and reminding us just how narrow the whole street must have been in medieval times. There are lots of familiar shop names from the 1960s: Dewhurst the butchers, the Arundel Café, Teddy Bear toy shop, Dorothy Perkins and Millett's on the left. Oliver's shoe shop, Timothy White's chemist and Lipton's grocery on the right.

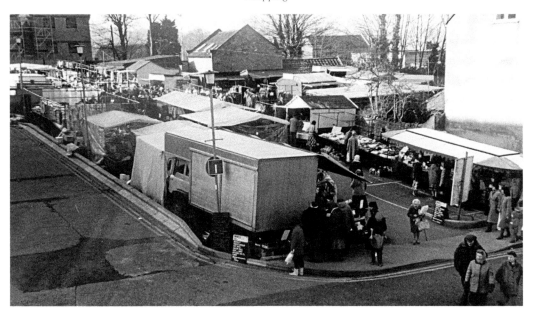

Before shops, of course, Yeovil had a market that was originally granted under a charter from King John in 1205, held in the streets in the centre of the town. In 1856 Vickery wrote, 'Corn, cattle, butter, cheese, hemp and flax are sold in great quantities.' In the mid-twentieth century the market moved to the Petters Way car park adjoining South Street, shown here in the 1970s. It is now held in the pedestrianised Lower Middle Street.

That Princes Street was originally called Cattle Market, northern Hendford was named Hog Market, North Street was Sheep Lane, and the top of Silver Street was Cornmarket conjures a picture of what Yeovil must have been (and smelled) like on a Friday. The animal market was gradually moved to what is now Court Ash car park (where it remained until the 1960s), and in the 1850s William Palmer established the animal market (seen here) between Court Ash and Reckleford.

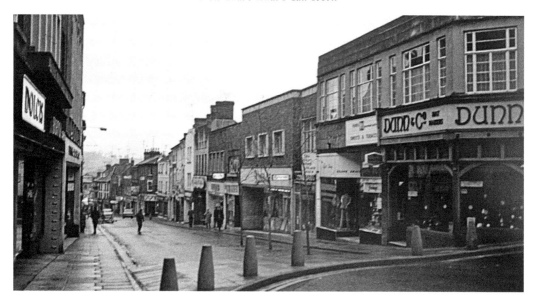

In 1962 the George Inn and Chubb's bakery were demolished and Yeovil's first supermarket, Elmo, built premises on the site (seen here in the centre), but by the time of this 1970s photograph it was occupied by the Finefare supermarket. For many years it was occupied by Primark, more recently by the 99p Stores and it is now a Poundland outlet. Next came the Skirt Shop and Slack Shack, a small tobacconist, then Dunn & Co., hat makers, on the corner.

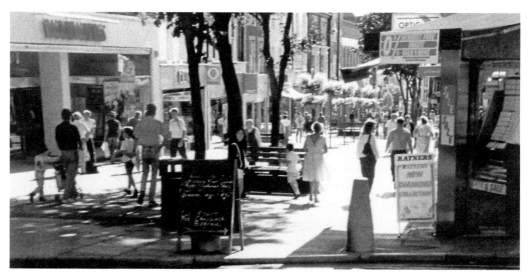

By the early 1980s national jewellery chain Ratner's had taken over from Dunn & Co. on the corner of Union Street – at least until 1991 when Gerald Ratner was asked how he could sell at such low prices and replied, 'Because it's total crap'. On the opposite side of Middle Street was Woolworths, established in Yeovil certainly from the 1920s with their famous catchphrase, 'Nothing in these stores over 6*d*.' Woolworth's closed in the winter of 2008–09.

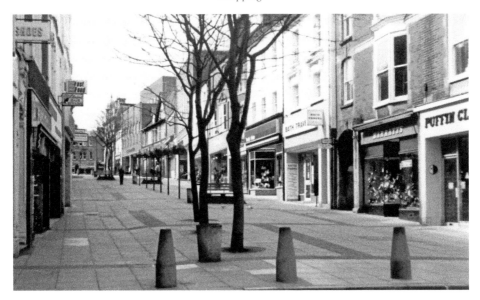

This photograph looks west along Middle Street in the late 1970s. Although the view is almost identical today, most of the shops have changed hands. Marks & Spencer in the red-brick building left of centre remains today, but to the right of the trees Timothy White's became Clark's shoes, Bath Travel was previously Lipton's and then Bellman's wools but became Thompson's Holidays. Barratt's shoe shop became a health food store and Pufflin Cleaners became Foto First.

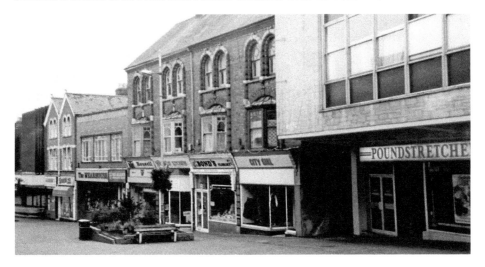

A Lower Middle Street parade of shops that too has had a range of occupiers through the years, although the buildings remain the same. In this incarnation are the Wearhouse working men's clothes store, with Sun Alliance insurance above, then Rousell the butcher (founded in 1888 in Wellington Street by Joe Rousell). Next was a small kitchen shop, then Bond's florist and City Girl clothes store. Finally, in what had been an outlet of Bejam, 'the freezer people', was Poundstretcher – today it is Poundland.

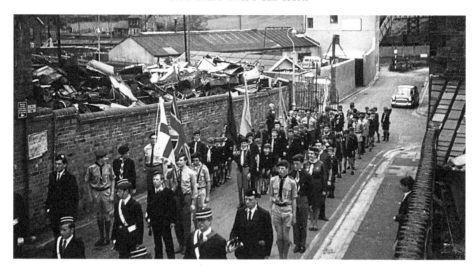

Sometimes you didn't want to buy things, but you might want to sell. So here we see the 1968 St George's Day parade assembling in Stars Lane outside Ernest 'Johnnie' Farr's scrap yard. Like his father before him, Johnnie Farr was dealing in rags and scrap metals from around 1910 until his death in 1946. E. J. Farr & Co. traded in Stars Lane until just after this photograph and today trade from the Buckland Road Trading Estate.

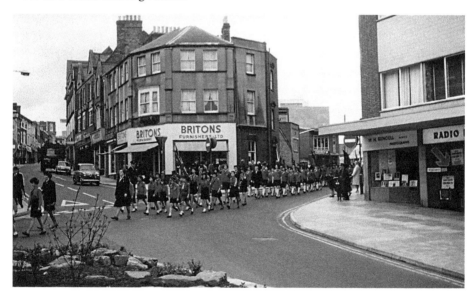

Be honest – do you remember a flower bed in the Triangle? This is a photograph of the same 1968 St George's Day parade as it enters the Triangle from Vicarage Street. Britons Furnishers Ltd had originally been James Belben's toy shop from 1850, expanding to become his *6d* Bazaar. It later became the Woolwich Building Society and today is Betfred bookmakers. On the right Rendell the photographer's premises became Jessop's photographic equipment retailers and on the extreme right Radio Rentals became First Choice travel agents.

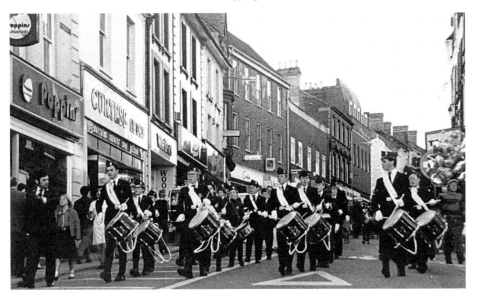

A very early 1980's St George's Day parade in Middle Street approaching the Triangle. On the extreme left Poppins later spent many years as Rosemary J's restaurant but in 2015 became Poppins once again. Curtess shoes then became Ladbrokes bookmakers and the wool shop next door is now Help the Aged – one of a myriad of today's charity shops. The next two shops are now a slot machine gambling establishment called Showboat.

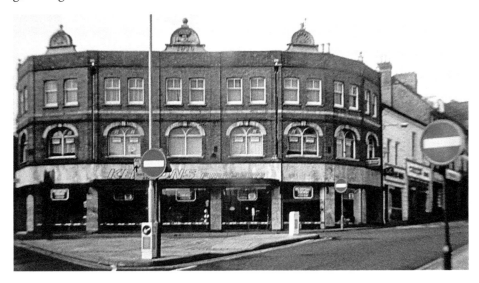

This is a 1980s photograph of the building in the Triangle built in 1910 for the Yeovil & District Co-operative Society as a retail space and offices above. After the Co-op vacated it had a variety of occupants including Harris Carpets and Kentons Furnishing. It then became a bargain-basement emporium. It spent several years as Porter Black's Irish theme pub between around 1995 and 2006, since when it has been a Chinese 'all-you-can-eat' venue initially called The Real China and now Beijing Magic Wok.

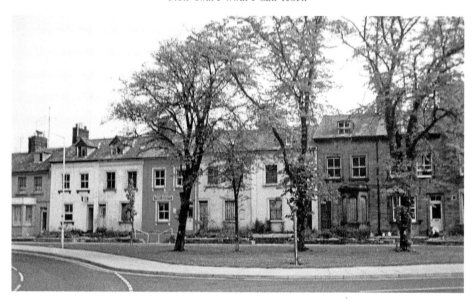

Station Road was built to connect the new Yeovil town railway station with Middle Street in 1860. South Western Terrace was built along the northeast side of the road and even in the 1960s, as here, there were no shops. Station Road was a convenient 'end of the line' bus stop close to the station before the bus station in Central Road was built. Shops started to appear in the 1970s, one of the earlier ones being the Yeovil Cycle Centre.

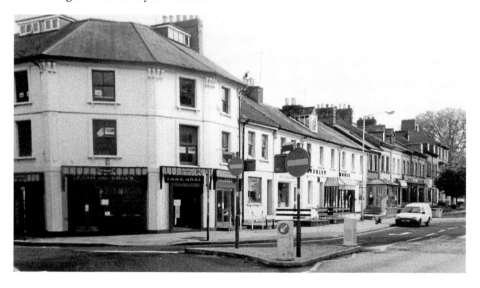

The London Commercial Temperance Hotel was built on the corner of Middle Street and Station Road in the mid-1860s, and renamed the Fernleigh Temperance Hotel by 1898. For many years after the Second World War the building was the offices of the Southern National bus company and Station Road was Yeovil's bus terminus before today's bus station was built in the 1960s. This photograph was taken in the 1990s when the building was occupied by Palmer's fish & chip shop.

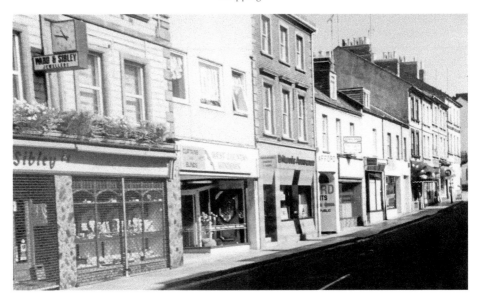

The building on the far left in this 1980s photograph, still occupied by Ward & Sibley today, was built in 1863 and in the distance the Elephant & Castle dates to 1860, but all the buildings between are earlier. There have been a large number of different occupiers through the years such as West Country Windows and Britannic Assurance seen here in the centre. Today chiefly occupied by fast-food franchises, the area is colloquially known as 'Takeaway Alley'.

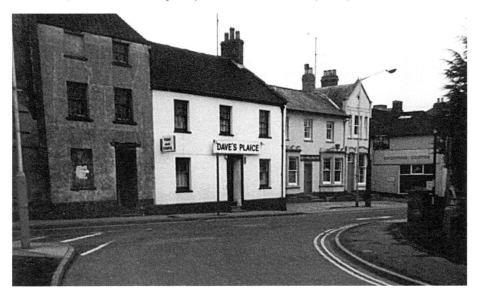

By 1983, the date of this photograph, it is fair to say that this run of buildings along Sherborne Road, at the junction of Townsend and Reckleford, was past its prime. However, many people fondly remember the three business featured here: Dave's Plaice fish and chip shop (later called the Fish Fryer), the Duke of Wellington and Cashman's Shopping Centre. The buildings were all demolished in 1992.

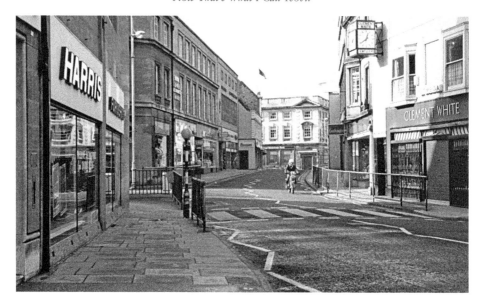

High Street in 1985 doesn't look much different to today. On the corner of King George Street, what had been Barclay's Bank from the 1930s to the 1970s was by this time Douglas Cant's newsagents, later Yeovil Cards & News, and today is a bookmaker's. Other notable shops were Tilzey's photographic retailers and Richard Shops' dress shop on the south side, while on the north side there was Clement White, Lennard's shoe shop, Gamis' Stores, later Dingles, later still Denner's and today Beale's.

Snow in the Borough just before Christmas 1987. Poundstretcher, on the corner of King George Street, was originally just two-storeys tall and built in the 1930s as Frederick Taylor's department store. It became three storeys during the 1940s and was occupied by Plummer's from the 1950s to the late 1970s, during which time it became four-storeys high. It was occupied by Harris Furnishing in the early 1980s (*see* above) and today it is Caffè Nero and TSB Bank.

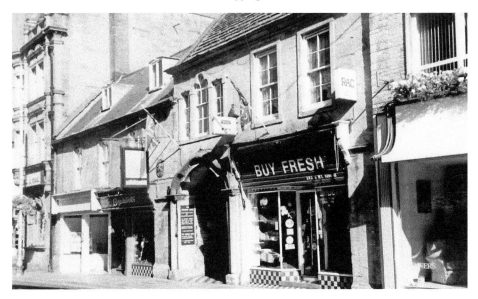

By 1942 a shop had been inserted to the right of the Mermaid Hotel's entrance and two inserted to the left by the early 1950s. By 1955 the first (left) was occupied by Gordon Price opticians, then Dollond & Aitchison opticians. It is now Mortimer's bakery. The middle shop was Braddick's tobacconist from the 1950s and only very recently moved to Westminster Street. The right-hand shop was Maynard's sweet shop in the 1960s, then Buy Fresh greengrocery and more recently a hair stylist.

The draper Lynsey Denner came to Yeovil in 1875 and bought the premises at No. 25 High Street, originally built in 1836 for drapers Edwards & Dean. Around 1911 he acquired the neighbouring property and further adjoining two-storey properties shortly thereafter. All the properties were converted to three, later four, storeys. Beales acquired the store in 1999 but kept the name Denners until 2011 when it was restyled as 'Beales'.

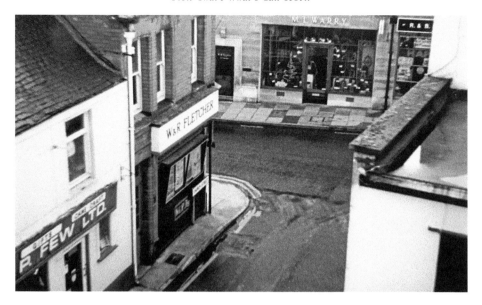

This unusual view of the junction of Church Street and Princes Street was taken in 1988 from the external helical steel staircase leading to the projection room of the Central Cinema just before its demolition. The red-brick building on the corner, here Fletcher's the butchers, was built in 1885 while the white building on the opposite corner, glimpsed on the extreme right, was Yeovil's main post office from 1876 until 1902. It was later the Chelsea Tea Rooms and today is an estate agent.

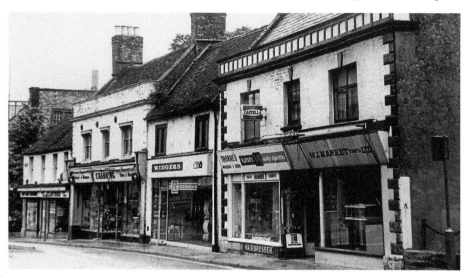

The earliest buildings in this area, Nos 40–52 Princes Street were built as four early eighteenth-century town houses (No. 44 is seventeenth century), and are now subdivided into seven shop premises. They are seen here in the late 1970s when No. 46 and No. 48 were Channing's toy shop, No. 44 was Widgers decorating stores, No. 42 was Thorne's hairdresser and tobacconist and No. 40 was the WI Market (before it moved to Hendford, near to the Butchers Arms).

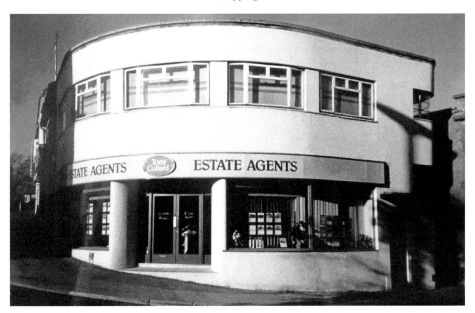

Often overlooked and underrated, this mid-1930s art deco-style building on the corner of Park Road and Princes Street was part of Yeovil's first 'new' shopping centre. Originally Burtol Cleaners, it was later occupied by Griffith & Palmer estate agents, then Tony Collard estate agent in the 1990s. In the 2000s it was occupied by Concept Staffing and is today Acorn recruitment and training agency premises.

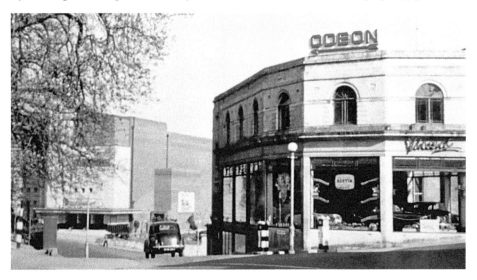

Two more buildings of the 1930s, seen here looking to Court Ash from Princes Street in 1984. The Odeon Cinema, seen on the left, went through a series of ownerships as a cinema but finally closed in 2001. It became the Old Cinema bed and sofa store and Studio 2 furniture store in the early 2010s. It is now St Margaret's Old Cinema Home Store. On the right is Vincent's car showrooms, which is now the offices of Battens solicitors.

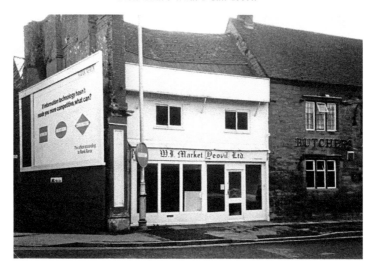

This 1984 photograph shows the WI Market next door to the Butchers Arms, Hendford. The building was the photographic studio of John Chaffin & Sons between 1868 and 1919. In the 1960s it was occupied by Yeovil Motor Cycle Mart and later by Moffat Marine. The building to its left had been Chudleigh's, the seed merchants, premises which were demolished for road widening in the 1960s. The WI Market building was demolished shortly after this photograph was taken. Today the plot is still vacant.

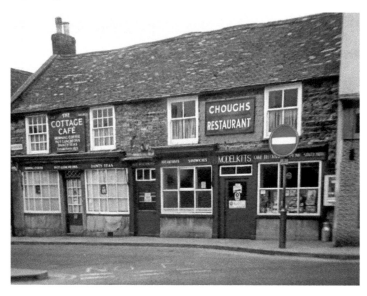

Many Yeovilians have fond memories of the Cottage Café in Hendford, on the corner of Waterloo Lane. The building itself is early eighteenth century and was built as a small town house. In 1928 William Banfield opened the Cottage Café, later run by his son, while Modelkits of the 1970s and '80s was run by his grandson Bob Banfield. In 1994 No. 16a was the premises of Premier Wines, then Humbert's estate agent, while No. 16b was the Yeovil Collector's Centre and is today Waterloo Music.

By the 1880s, in West Hendford between the junctions of Salthouse Lane and Wellington Street, a candle factory had come into existence. After the Second World War the factory had become a groceries distribution centre – an early 'cash and carry' for small independent grocery shops. By the 1980s, and well into the twentieth century, it became the premises of Taylor's Paints, as seen here. This building is the last remnant of Wellington Street and still bears the street nameplate.

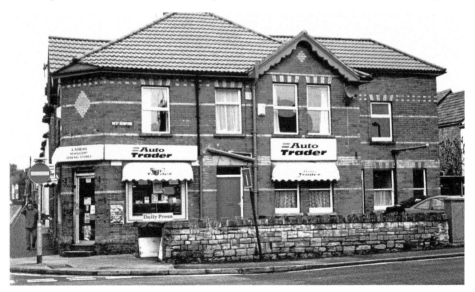

Harold Robins, the third generation of Yeovil shopkeepers, bought this shop on the corner of Beer Street and West Hendford in 1927. The building had been purpose built as a shop in 1888. After Harold retired, his son Tony Robins took over the shop, which became a daily stop for hundreds of workers on their way to Westlands, just down the road. Tony retired, and this famous corner shop finally closed in 2002. It is now Smartees day care nursery.

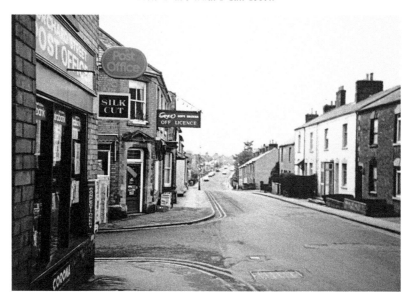

In the pre-supermarket age of 1954, Yeovil had at least sixty-nine small grocery stores, often situated on street corners, and many Yeovilians know Montague's Convenience Store on the corner of Orchard Street and Huish. It had been the grocery and undertaker's business of the Cook family (now of Bond Street). The Montague family bought the shop in 1958 and the post office on the opposite corner in 1977. Although the post office closed several years ago, the corner shop still operates today.

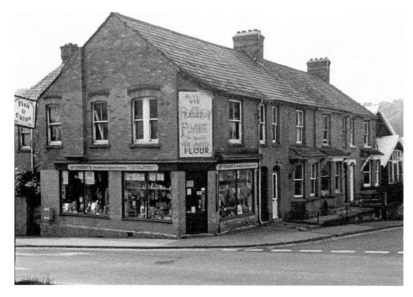

Another purpose-built corner shop, built around 1905, this time on the end of Harfield Terrace, Addlewell Lane, at its junction with South Street. In the 1960s, '70s and early '80s, as photographed here, it was Samuel McCreery's well-known junk shop (sorry, pre-owned bric-a-brac emporium). By the 1990s the shop was occupied as the Red Cross shop and since around 2005 has been Vita Capelli unisex hairdressing salon.

Photographed here from Clarence Street in the early 1990s, it is now quite difficult to remember Tesco car park when it was just single storey. Of course, the car park at this time was relatively new, having been built on the site of the famous sloping football pitch of Yeovil Town Football Club's home ground at Huish in 1991–92. The upper deck of the car park was added around the year 2000.

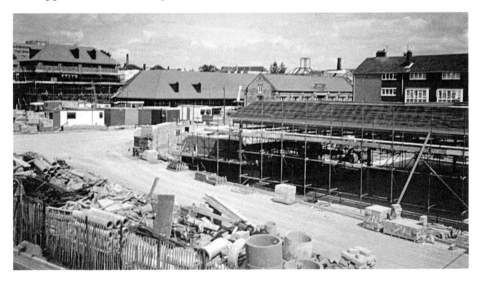

This photograph, also from the early 1990s, was taken from the footbridge over Queensway and shows the construction of the Tesco petrol station in the foreground. The rise of the supermarket filling stations during this period coincided with the demise of the several small petrol stations dotted around Yeovil: South Yeovil Service Station in South Street, Tony Chant's in Huish, Vincent's in Market Street, Douglas Seaton's filling station in West Hendford, as well as filling stations on Hendford Hill, St Michael's Avenue and West Coker Road.

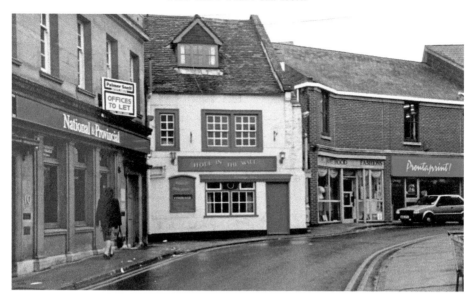

Renamed the Hole in the Wall during the late twentieth century and seen here in 1985, it had been trading at least since 1766 and was originally known as the Queen's Head, then the Queens Arms, then the Royal Oak. It became the Green Room restaurant around 2005. On the left the National & Provincial is today a school uniform shop. Janet Wood Fashions (in the building that replaced the Cadena in 1983) and Prontaprint are occupied today by a tattooist and a hairdresser.

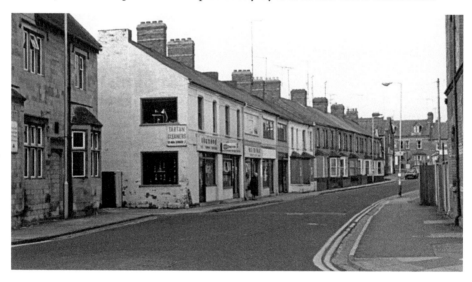

Vincent Street was built by William Tucker in the 1890s on orchard land lying between Reckleford and Vicarage Street. This north–south section, between Vicarage Street and Vincent Place, was completely demolished in 1983 for the development of the Quedam shopping centre. It was home to the shops shown here: Tartan Cleaners, Shumend, War on Want and Mervyn's hairdresser. Further down, at the junction with Earle Street, was the 'Vincent and Earle Street Stores' corner stores.

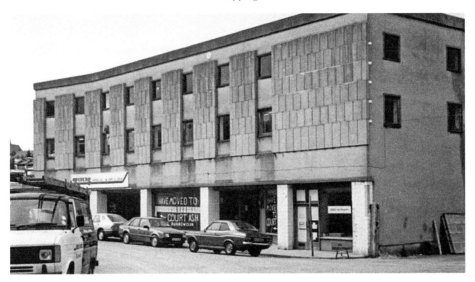

Many Yeovilians will remember the ironmongers and builders' merchants Neil & Williams that traded in Yeovil from the 1890s until the early 1970s. They were based in Middle Street but also operated this large building in Vicarage Street, which, during the Second World War, housed the Yeovil War Workers' Club. By 1962 Neal & Williams used these premises as a builder's merchants and the premises at Middle Street as a general ironmongery outlet. This building was demolished in 1983 for the Quedam project.

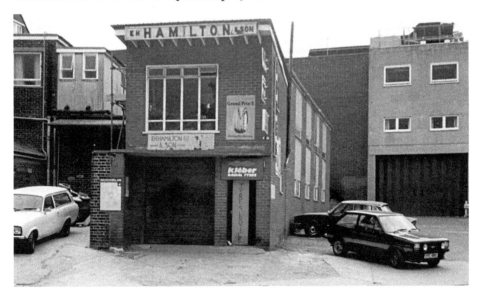

Hamilton's Tyre & Battery Service was established in Vicarage Street (opposite the Methodist church) in 1928 and later traded as E. H. Hamilton & Son. During the 1960s it was run by the founder's son, Bill, and later by his grandson Ian. This building was also demolished in 1983 for the Quedam project and the site of it is now occupied by the Laura Ashley shop in Ivel Square.

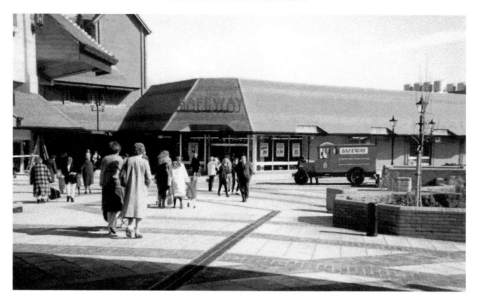

One of the first premises of the new Quedam shopping centre to open was the Safeway supermarket in Ivel Square, photographed here in the early 1980s shortly after it began trading. The Safeway chain was acquired by the Morrisons Group in 2004, by which time the store had moved to Lysander Road. The premises were later occupied by the British Home Stores but in the summer of 2016 BHS went into liquidation, reopening as an online-only store.

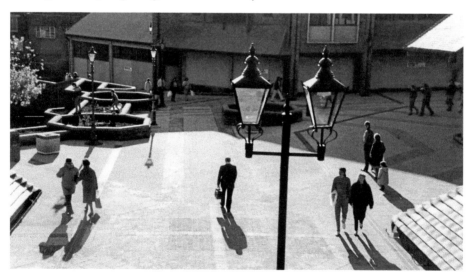

This unusual view of Ivel Square, in the Quedam Shopping Centre, was taken from above the Safeways store of the above photograph at around the same time. It looks in the opposite direction and shows Vicarage Walk running off to the right and the slope down to the former eastern end of Vicarage Street off to the left. In the background are the shops that have been completed but yet to be occupied by the Alliance & Leicester, a hairdressers and Laura Ashley.

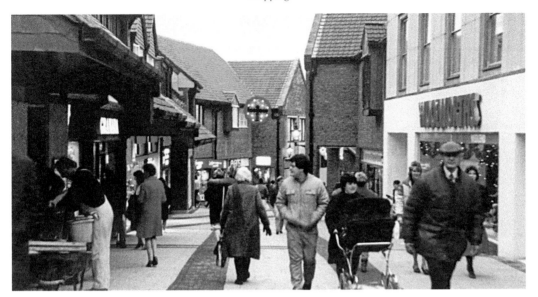

By the mid-1980s, the date of this photograph looking along the western end of Vicarage Walk, the shops of the new Quedam shopping centre were fully occupied. The shopping centre was invariably busy with shoppers, not just from Yeovil but from the whole surrounding district. There has been a considerable turnover in occupiers through the years and recent rebuilding of a few new stores on the left of this photograph has been an effort to revitalise the centre.

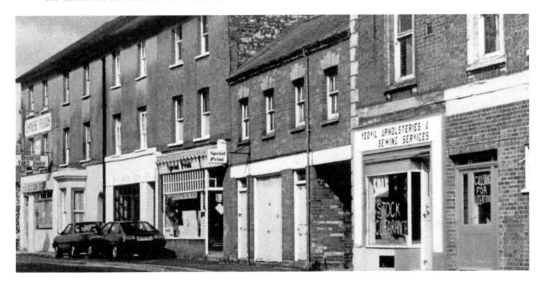

Finally in this section, this is a photograph of Wyndham Street taken in the late 1980s. At this time it was somewhat rundown with a Chinese takeaway on the far left, Sprint Print in the centre and the Yeovil Upholsterers & Sewing Services on the right. Today this side of the street has been smartened up with Domino's Pizza, a different Chinese takeaway and a Polish delicatessen. Perhaps most surprising is that the two-storey building is now a three-storey building.

LEISURE

There has always been a lot to do in Yeovil if you had any leisure time, even if it was just a stroll along the banks of the River Yeo or across the fields of Wyndham Hill, Summerhouse Hill or Constitution Hill that flank the southern edge of the town. Victorian newspapers are full of reports of people enjoying theatrical and musical performances, recitals and so forth. The Yeovil Military Band would frequently parade through the streets or give performances in the open air. There were all manner of clubs and societies that individuals could join and enjoy. The tradition continued throughout the twentieth century and, indeed, continues today.

From early times travelling theatrical companies visited the town, giving performances in a range of makeshift theatres until the Assembly Rooms opened in Princes Street in 1888. Many will remember amateur dramatic and operatic performances here, as well as dances, rock bands and even the 1960 Yeovil Boat Show (how on earth did they get boats in there?). Johnson Hall, now the Octagon Theatre, opened in 1974 as Yeovil's new multi-purpose civic hall and in 1976 the first performance was given in the new Swan Theatre. The Assembly Rooms was also the first venue in Yeovil to show films in 1896, but by the mid-twentieth century Yeovil had three purpose-built cinemas; the Central Cinema (last film shown in 1964), the Gaumont (a bingo club from 1972) and the Odeon (under various ownerships) until 2001.

For the more active there has always been a large range of sports to enjoy, such as swimming, football, athletics and even skiing. Mudford Road Playing Fields – now officially called Yeovil Recreation Centre but still affectionately known by Yeovilians as 'Mudford Rec' – opened in 1931. Today, in addition to the fields themselves with their several football pitches, it boasts a superb athletics arena with an all-weather track, an artificial grass pitch, tennis courts, a pitch & putt course and a large children's playground.

For the less energetic, darts and skittles have been enjoyed for generations, especially since both usually are practiced in pubs (I personally preferred rifle target shooting since I could actually lie down while taking part). Or, of course, you could be a spectator and Yeovil Town Football Club has enjoyed a large and enthusiastic body of supporters since its inception.

Many organisations have facilities in the town, such as gymnasia and fitness centres, bowls, golf, and so on for both members and the public.

Children's play areas have been well established since the 1950s at various locations in the town, and many youth clubs, often run by the town's various churches, have always been popular, as have youth organisations such as the Scouts, Sea Scouts, Girl Guides, Boys' Brigade and their younger counterparts, Cubs, Brownies and the like. For young (and occasionally not-so-young) adults a string of discos and nightclubs was popular throughout the latter half of the twentieth century.

Being a country town, Yeovil has always enjoyed agricultural shows and horse trials and the Festival of Transport in the showground was always well attended.

This chapter of the book looks at just a representative few of the sports, pastimes and leisure pursuits enjoyed by Yeovilians.

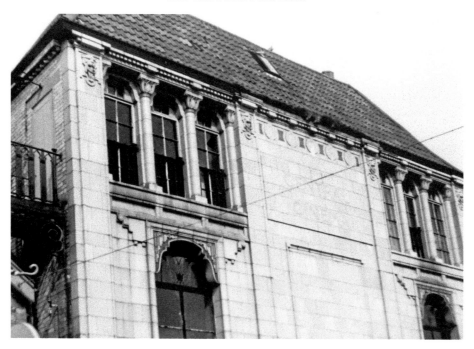

Yeovil's first purpose-built cinema, named Yeovil's Cosy Corner, opened in Church Street in 1912 and was renamed the Central Hall Cinema by 1916. It burnt down in 1930, was rebuilt in an art deco, neo-Egyptian style and reopened in 1932. The last films were shown here in 1964 and it had a brief revival as a casino and then a bingo hall. It finally closed in 1979 and remained empty until it was demolished in 1988.

A new cinema, the Gaumont Palace, opened in 1934 on the corner of South Street and Stars Lane and was hailed as 'one of the most luxurious picture theatres in the provinces'. In 1967, renamed the Classic Cinema, bingo was introduced on several days a week, and proved so successful that the Classic finally ceased to show films in November 1972. It closed as a bingo hall in 2009 and reopened as a nightclub in 2010.

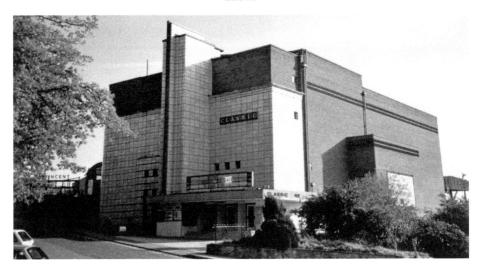

The 1,580-seat Odeon Cinema, in Court Ash, opened in 1937. The 'Odeon Style' used signature cream faience tiles and brickwork to create a towering art deco-based edifice. In addition to the distinctive lettering of the logo, the Odeon's design used contrasting strong vertical and horizontal lines, curved corners, the use of neon lights and contemporary interior decor to ensure it stood out from its rivals. The cinema was bought by Cannon Cinemas in 1972 and finally closed as a cinema in 2001.

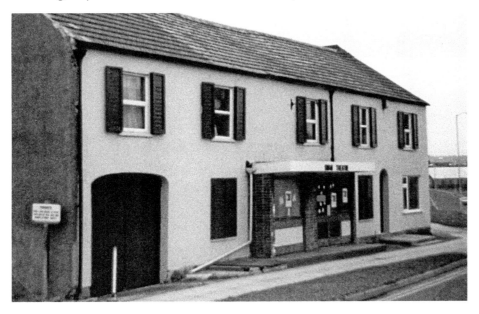

The Swan Inn, Park Street, began life as a beerhouse and was certainly trading in the 1830s. In 1967 Charrington sold the Swan, by this time derelict, to the local dramatic society. For seven years members worked to transform the pub into their headquarters, although performances still had to take place in hired halls. The society then converted the old pub into its own theatre. The first production in the new Swan Theatre was in 1976.

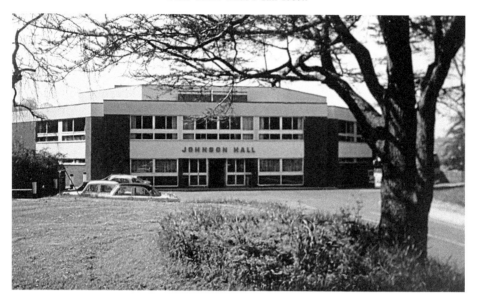

After a fire destroyed the Town Hall in 1935, the council decided that a new civic centre complex was needed, including a new civic hall. In 1948 a fund for Yeovil's civic hall was started. It was designed in 1961 but building didn't actually start until 1972 and the Johnson Hall opened in 1974 as a multi-purpose civic hall at a cost of £150,000. In 1985 it was renamed as the Octagon Theatre.

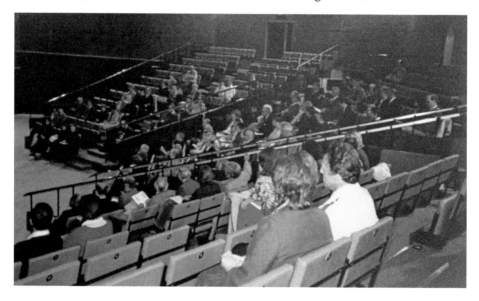

Initially the Johnson Hall had raked seating that was retractable and seen in this photograph of the early 1980s. With the seating retracted, it allowed the floor space to be used for a whole range of events such as dances, collector fairs and, certainly in the 1970s, wrestling matches on a temporary wrestling ring erected in front of the seating. The decision was taken to replace the retractable seating system with permanent raked seating suitable only for watching stage performances.

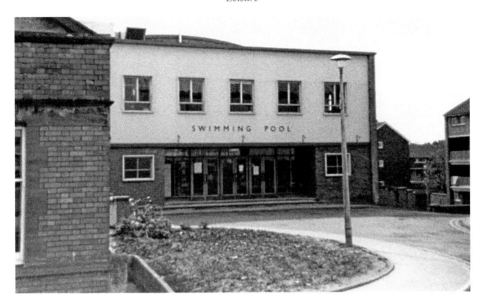

Yeovil's first public swimming pool and baths opened in Huish, on the corner of Felix Place, in 1885. Although enlarged and modernised more than once, the Huish pool was finally demolished in 1960 when it was rebuilt. The new building, fondly remembered by many Yeovilians and seen here in 1983, was three-storeys high and had raked seating for spectators. The swimming pool was, in turn, replaced by the Goldenstones Pools & Leisure Centre, which opened in 1992.

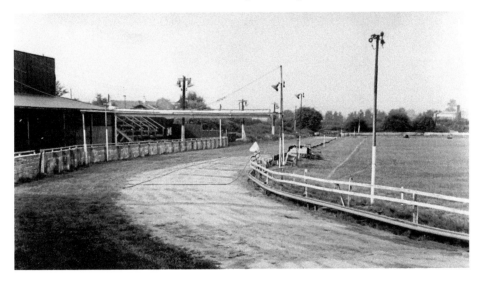

The purpose-built greyhound track in Yeovil was based at the Larkhill Stadium on Larkhill Road and first opened its gates in 1947, built on fields that had originally been part of Larkhill Farm. The stadium was able to accommodate 20,000 people and there was a licensed club and bar. The centre of the track was used for other sports including football. The stadium closed in 1972 and today the site is housing of Larkspur Crescent.

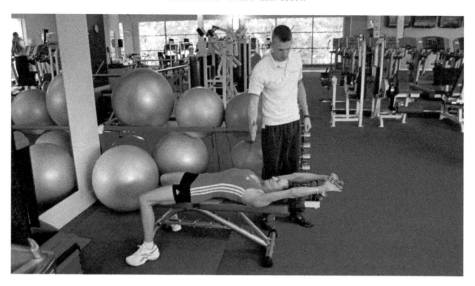

During the latter half of the twentieth century, with the rise in awareness of health and fitness, a whole new industry came to Yeovil. Fitness centres and gyms began opening across Yeovil, initially in schools such as Preston, Westfield and Yeovil College as well as private members-only centres. At the same time fitness classes such as aerobics, step and yoga sprang up in almost every suitable local venue. In the 1990s the Goldenstones and Canons (now Nuffield Health) fitness centres opened offering a full range of facilities.

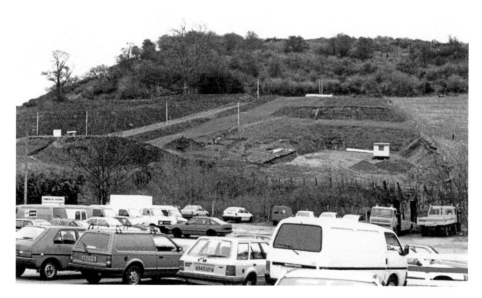

In the late 1980s a new ski and entertainment centre was built off Addlewell Lane, on a 2.26-hectare site on the western flank of Summerhouse Hill, seen here under construction in 1987. As well as an entertainment venue, it had one 110-metre Dendix artificial ski slope with four jumps ranging between 0.3 metres and 1.8 metres in height. Both the entertainment venue and the ski centre closed in 2007.

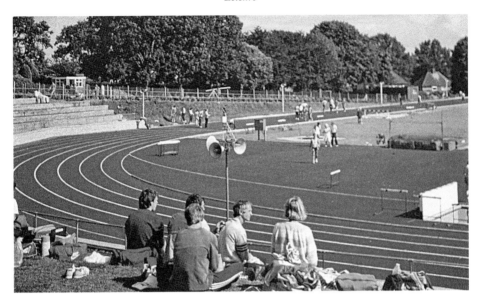

Mudford Road Playing Fields were opened in June 1931 and extended in 1954 and again in 1959. Hard tennis courts opened in 1963, and in 1970 the pitch and putt opened. The following year Mudford Road Playing Fields were renamed Yeovil Recreation Centre. To enable a long-requested athletics track to be built, in 1970 Somerset County Council sold a small piece of their land at Little Hollands to the Borough Council.

Whether you were a young mum with children playing on the fields or in the children's playground, a group of friends having a lunchtime kick around, tennis players, more serious amateur Sunday League footballers, or just someone having a walk across the playing fields, you will probably have fond memories of the Yeovil Recreation Centre's café/toilets/changing room complex – photographed here in the mid-1980s.

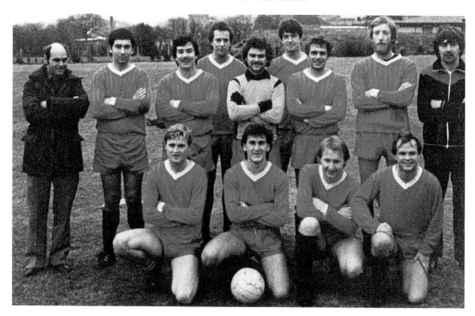

This photograph is representative of all those amateur Sunday morning footballers, 5-a-siders, rugby teams, netball teams, and so forth. The photograph is of Yew Tree Football Club and was taken at Lysander Road around 1983. To quote one of the players: 'We got changed in a garage, washed in a bucket, but loved every minute of it' – the characteristic ethos of such enthusiastic Yeovil teams and their players.

With the rise in awareness of health, fitness and exercise during the late 1970s and early 1980s, a number of fitness instructors began running classes of aerobics and step aerobics in various school halls, church halls and other venues in Yeovil. With the large leisure centres introducing similar classes free for their members during the 1990s, it brought about the inevitable end of these independently run classes.

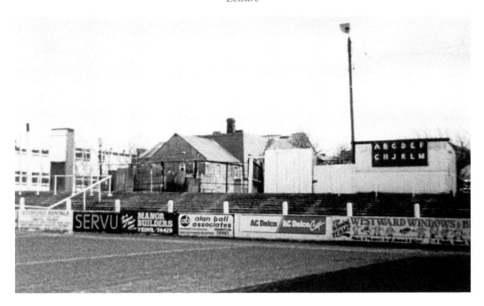

Surely the most popular leisure activity for a huge number of loyal fans was following the town's football team. This photograph of the mid-1980s shows the Brewery End of Yeovil Town Football Club's home ground at Huish, so called because it backed onto the buildings of Brutton's Brewery that flanked Clarence Street. The pitch was, of course, famous for having a 2.4-metre (8-feet) sideline to sideline slope.

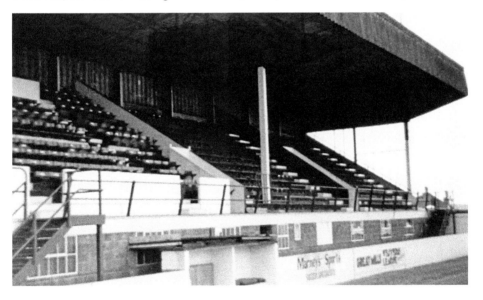

Yeovil Football Club was founded in 1890, renamed Yeovil Casuals in 1895, and played at West Hendford. Their next home ground was the Pen Mill Athletic Ground but moved to Huish in 1920. The name Yeovil Town was adopted in 1907 but became Yeovil & Petters United on amalgamation with Petters United, finally reverting to Yeovil Town around 1946. This photograph of the main stand at the club's home ground in Huish dates to around 1985. The stand was demolished in 1991.

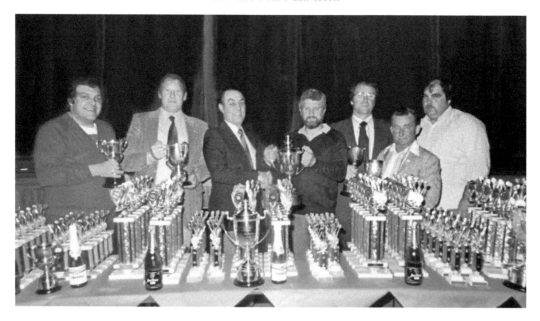

The game of darts can be traced back many hundreds of years, although the dartboard with the numbering layout of today was invented in 1896. The game has probably been played in most Yeovil pubs from shortly thereafter. This photograph shows the captains of the winning teams of the Yeovil & District Darts League during the 1982/83 season presentation evening at the Johnson Hall. The sheer number of awards on display points to the lasting popularity of the sport.

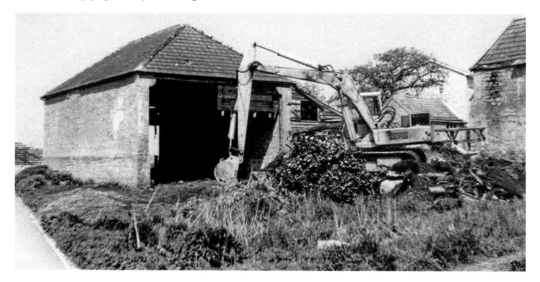

The Old Barn Club originated from a meeting, held at the Yew Tree Inn in May 1977, of people who lived in the area and were interested in doing something to celebrate the Queen's Silver Jubilee. The idea was born to convert the derelict barn on the old Yew Tree Farm as a community project by local people, with help from a local builder. This 1977 photograph shows the original old barn as conversion work started.

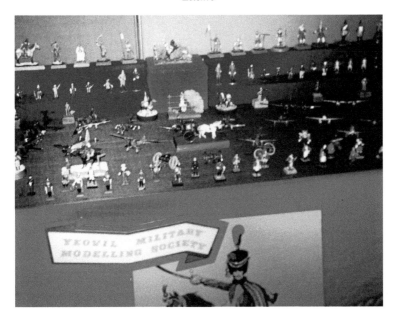

The Yeovil Military Modelling Society was a small group of modelling enthusiasts who held regular monthly meetings during the 1970s and into the early 1980s. As well as general discussions about anything military, monthly themed competitions of military miniatures were held and this photograph, from 1977, shows part of an exhibition put on by members of the society in the St John's Schoolrooms in Church Street.

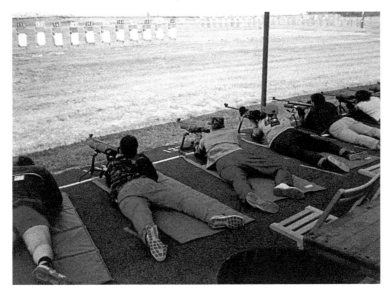

Target rifle shooting was a popular sport in Yeovil from Victorian times. The Westland Rifle & Pistol Club's home range was on the site of the former Westland Sports & Social Club, and members regularly visited other shooting clubs in the South West. This 1989 photograph shows members of the club at a national small-bore target rifle competition at the National Shooting Centre at Bisley, Surrey.

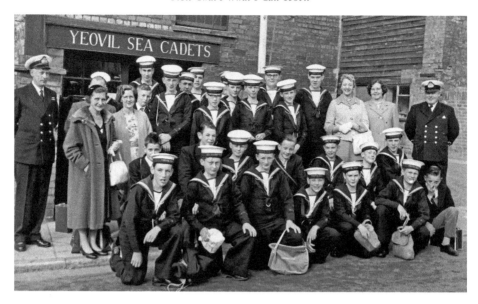

Yeovil and District Sea Cadet Corps, photographed here around 1961 outside the HQ in Central Road, is included here as representative of all Yeovil's youth organisations such as the Boys' Brigade, Scouts, Guides and their younger counterparts; Anchors, Beavers, Cubs, Brownies, etc. The Yeovil Sea Cadets were founded in 1953. They moved in 1996 and are now based at the Royal Naval air station, Yeovilton (HMS *Heron*), which has always been closely associated with Yeovil.

This green tin hut, on the corner of Addlewell Lane and Mill Lane, was the Holy Trinity church hall. As well as normal church functions, the scouts used to meet there. However, most 'baby boomer' Yeovilians will remember it as one of Yeovil's first youth clubs in the early 1960s called Teen Beat. Teen Beat was run by Fred Cotterell and for just *6d* you could spend every Tuesday evening dancing to Steve Stimpson and his band. The site is now flats.

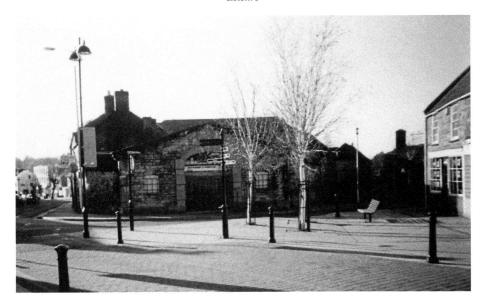

Moving on to the 1970s and '80s and the trend moved towards discos and nightclubs. One venue that will recall many memories was Carnaby's (later Duke's) in Tabernacle Lane. This photograph is of another venue, at the junction of Hendford and West Hendford, originally the stables then garaging of the Three Choughs Hotel, but converted into function rooms called the Camelot Suite in 1973. It later became Oliver's, then the Electric Studios. The site is now flats.

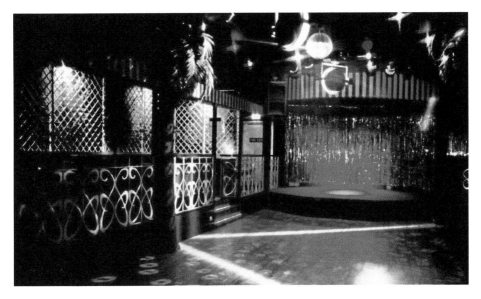

At the beginning of the 1970s Maggie's Club, later Pandora's, opened in a former glove cutting factory in Court Ash. Some ten years on and the Gardens restaurant and nightclub opened in Clarence Street, seen here just before it opened in 1981 (who can ever forget dancing around the palm trees?). It later became Le Jardin but today the site is – yes, you've guessed it – more flats.

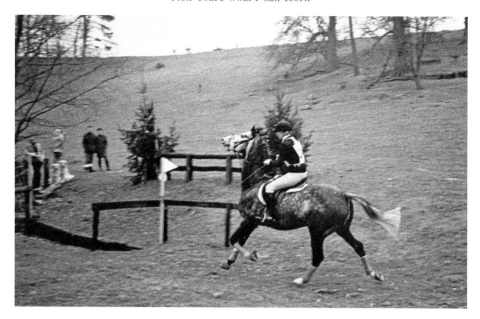

Being a market town set in the heart of the countryside, Yeovil has always enjoyed a close association with the culture of its farming hinterland. The Aldon estate, on the southern boundary of the town, holds three-day international horse trials every spring and autumn. However, the event held in 1984 was a little special since the Olympic equestrian Princess Anne, seen here, took part in the event.

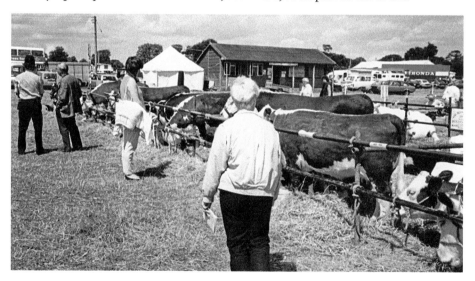

Yeovil has a long tradition of holding agricultural shows, indeed being the venue for the 1856 Bath & West Show. This photograph was taken at the one-day annual show of the Mid-Western Agricultural Society, held at Barwick Park in July 1986. The show, attracting some 25–30,000 visitors, included classes for cattle, sheep, horses, goats and rare breeds. As well as an exemption dog show, exhibitions included horticulture, floral art, home crafts, rural crafts and an organic food hall.

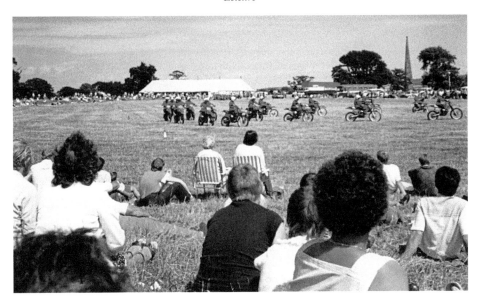

During the 1970s some of the shows tried to include a wider range of activities and displays. Here, for example, crowds gather around the central arena at Barwick Park (notice one of the park's four follies, the Needle, top right) to watch a display by a motorbike display team. Gradually the emphasis shifted from agriculture and the Yeovil Festival of Transport was to take over, continuing through the 1980s and '90s.

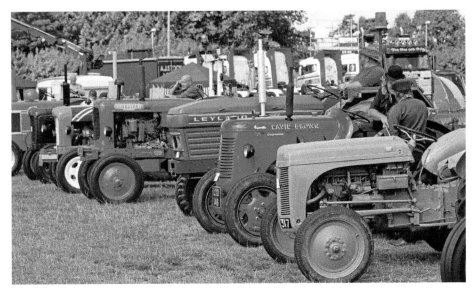

In 1972 by the Yeovil Car Club hosted a one-day show, the Cavalcade of Motoring, at Sherborne Castle and in 1975 it moved to Yeovil. In 1977 it was renamed the Yeovil Festival of Transport. The festival's objective was to raise enough money to purchase an ambulance or minibus for the disabled, sick, elderly and underprivileged. The 2003 show saw the fourteenth vehicle go to a charity. Yeovil Car Club decided to close down the Yeovil Festival of Transport after the 2003 show.

TRANSPORT

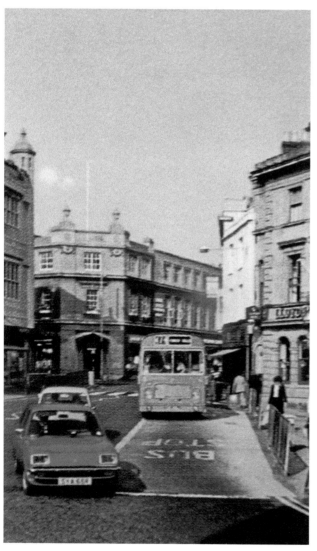

Transport has always been important to Yeovil and, as a market town, the farming hinterland made great use of the horse and cart from early times to bring produce to market. Yeovil was on the main London to Exeter stagecoach route – remembered today with the Quicksilver Mail Inn, named after the famous mail coach. However, the town grew rapidly and considerably when the railways arrived in the 1850s, helping to grow the important leather and gloving industries in the town.

After the Second World War bus services improved, both within the town and the district, especially when the new bus station was built during the 1960s as the northern part of the Glovers Walk scheme. The 1960s also saw the loss of much of Yeovil's rail network and the closure of the Town Station.

Although few people realise it, many Yeovil buildings had been lost through the last two centuries for road widening, but during the 1970s and '80s major new road schemes – Reckleford, Kingston and Queensway – had a far more noticeable effect.

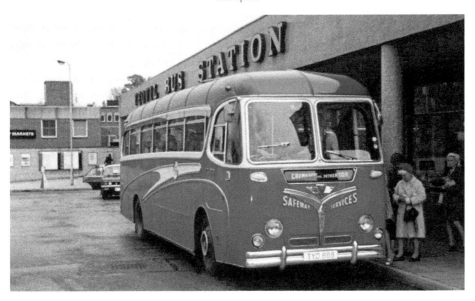

Until the 1960s Station Road had effectively been the Yeovil bus terminus, but when the Glovers Walk scheme was built in the 1960s, the northern part of the scheme was Yeovil's new bus station – seen here in 1974 with Key Markets in the background. For the technically minded, the bus is a Duple Elizabethan bodied AEC Reliance and was almost twenty years old when it was acquired by Safeway from Wake's of Sparkford the same year.

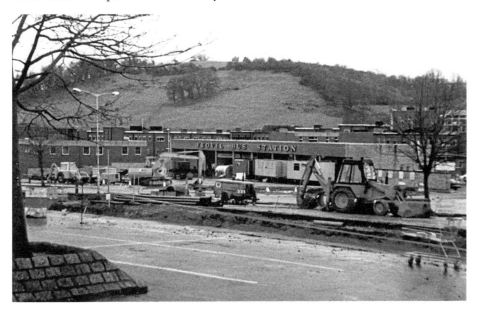

Yeovil bus station seen from Central Road in the early 1980s with the northern slopes of Summerhouse Hill seen in the background. The roadworks were part of the new Quedam shopping centre scheme, which, at the same time, was modernising the approaches to the bus station, but effectively closing the station for a brief time.

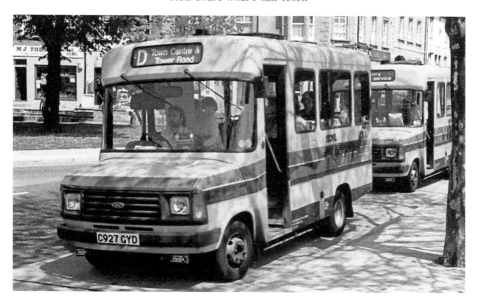

During the 1970s and '80s the bus services within Yeovil improved and these new, smaller buses became a common sight during the late 1980s. The buses seen here are parked in the bus stop lay-by outside the new Canons Health Centre (now Nuffield Health). In the background is the Alexandra Hotel. These buses were Ford Transits with body conversions by Robin Hood. This particular vehicle was first registered in 1985.

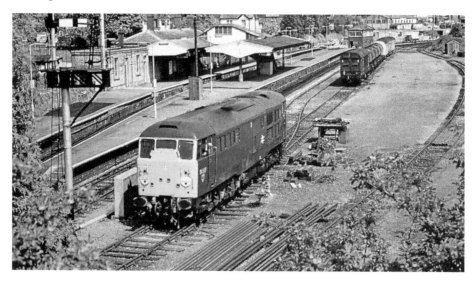

Still operating today, Pen Mill railway station was opened by the Great Western Railway as part of the Wilts, Somerset & Weymouth Railway route in 1854, with a branch to Hendford completed the following year. The Pen Mill locomotive depot operated until 1959 and the service between Yeovil Junction and Pen Mill was withdrawn in 1968. The route between Yeovil Town Station and Pen Mill Station has been incorporated into the National Cycle Network and is known as Railway Walk.

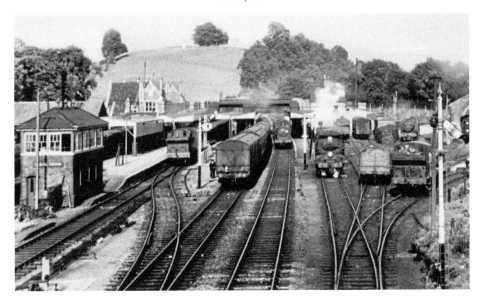

Seen here in 1961, exactly 100 years after opening, Yeovil Town railway station was a joint station built by the London & South Western Railways and the Great Western Railway and was well known for having two station masters. Yeovil Town Station closed to passenger traffic on 3 October 1966, but freight and parcels traffic continued to use the station until 9 October 1967 when these services were also withdrawn.

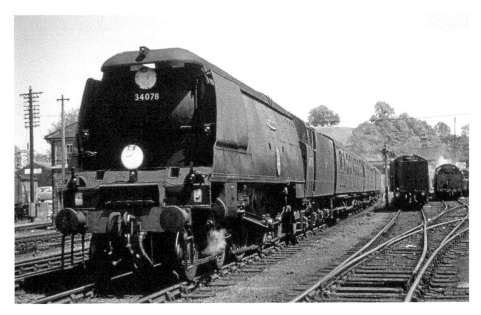

Photographed in Yeovil Town Station, with the trees surmounting Wyndham Hill in the background, this photograph is representative of the huge number of steam trains that passed through Yeovil in its heyday. This particular locomotive, No. 34078 222 Squadron was built in 1948 but, like Yeovil Town Station, didn't survive the 1960s and was withdrawn in 1964.

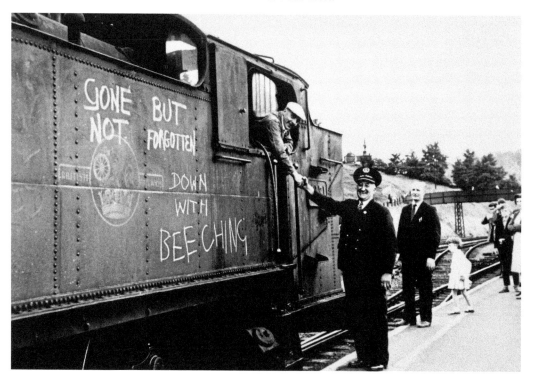

The 'Beeching Cuts' refer to the reduction of route network and restructuring of the British railway system outlined in two reports written by Dr Richard Beeching and published by the British Railways Board. National protests resulted but Beeching's name is, even today, associated with the mass closure of railways. First of Yeovil's stations to go was Hendford Halt in 1964 along with the line to Taunton. This photograph shows the last train from Yeovil to Taunton in 1964.

This very late 1960s photograph, taken from the lower slopes of Summerhouse Hill, is a very sad sight for many Yeovilians since it depicts the demolition of Yeovil Town Station. Although the buildings remain, the railway tracks have been removed and the buildings, a familiar sight for generations, would soon disappear too.

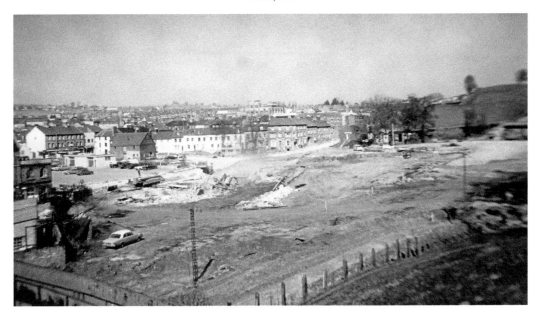

Taken just a few months after the previous photograph and from almost the same place, all traces of the former railway station have now disappeared apart from the red-brick building left of centre. This building had its own railway siding and was part of Burt's coal yard. It too disappeared shortly after this photograph, which does, however, give a really good view of South Western Terrace.

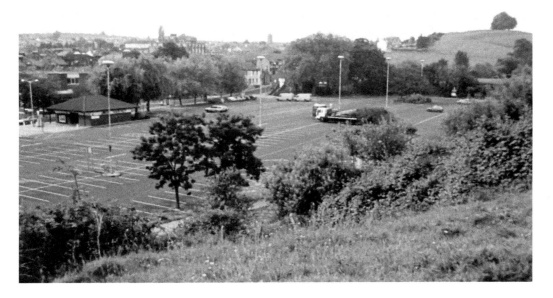

Moving on in time once again, the cleared site of the town station has now been transformed into Old Town Station car park. Complete with its block of public lavatories (much to the relief of visitors to this end of town), note too that this was before the extension to the car park was added beyond Newton Road. Much of this scene would disappear when the Yeo Leisure Park was built.

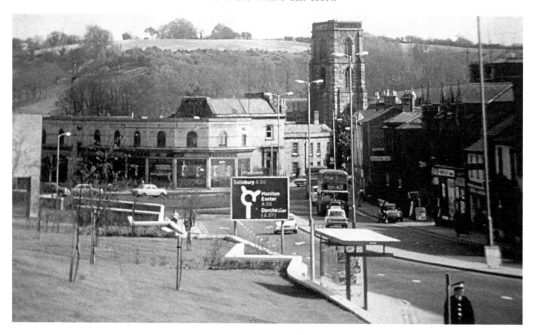

Major road works disrupted Yeovil throughout the latter part of the twentieth century. In the 1970s Reckleford was transformed from a fairly quiet suburban street into a car-focused urban motorway – not many towns can boast a bypass that goes through its centre. This was followed by the widening of Kingston to a dual carriageway and building the new Queensway dual carriageway – all resulting in a large loss of existing buildings.

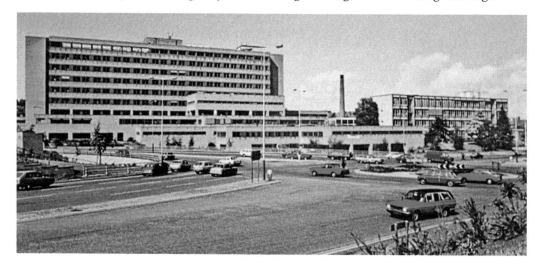

All the buildings in Kingston on the right of the previous photograph were demolished to create this 1980s view of the newly opened Queensway as it approached the hospital roundabout. At this point the new dual carriageway met Kingston (off to the left) and Reckleford (off to the right) – both themselves newly transformed into dual carriageways. Queensway resulted in the loss of Queen Street, much of the Crescent and half of Everton Road.

GREEN SPACES

Despite the loss of significant parts of Yeovil during the latter half of the twentieth century through major building schemes or road projects, as witnessed by much of this book, there remain some quiet, open spaces.

Yeovil is indeed fortunate to be nestled in the middle of glorious countryside and Yeovilians are lucky to have free access to such delightful places as Summerhouse Hill and Wyndham Hill. While both offer spectacular views across Yeovil and the surrounding landscape, there are also a range of parks and walks within the town itself. Some have disappeared during the timeframe of this book while others have been created. This final chapter looks at some of these places, beginning with this view of Lover's Lane. Following the line of the original Roman road from Ilchester to Dorchester as it climbed Hendford Hill, this lane still offers a quiet place to walk amid nature, although you will actually only be yards from modern housing.

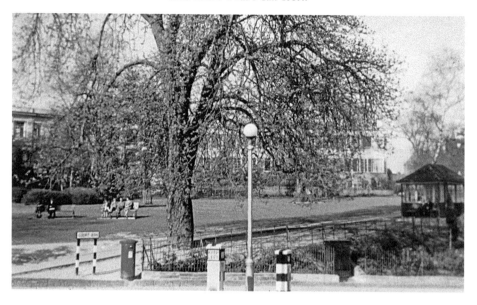

Bide's Gardens were donated to the town by Thomas William Dampier-Bide. He lived in Kingston Manor House and on his death in 1916 bequeathed to the town a large part of his grounds, lying between Higher Kingston, Court Ash, Court Ash Terrace, Kingston and Red Lion Lane, known thereafter as Bide's Gardens. Yeovil lost Bide's Gardens in the 1970s with the building of the Yeovil District Hospital and the widening of Reckleford.

Sidney Gardens, a 3-acre triangle of open space, was presented to the town by Mayor Sidney Watts to commemorate the 1897 Diamond Jubilee of Queen Victoria. James Bazeley Petter presented the bandstand to the town and this photograph of the 1960s shows a crowd enjoying the music of the band. Built of wood, the bandstand was vandalised and burnt down in early 1973. Today the park remains a quiet haven, just a short walk from the town centre.

Ninesprings is a broad-leaved woodland valley of some 20 acres on the south-east edge of Yeovil with nine springs supplying water to small streams and ponds. It was developed as an ornamental park for the Aldon estate during the early nineteenth century and included walks, bridges, grottoes, springs and lakes. The picturesque thatched cottage once served cream teas but then suffered neglect and was finally demolished in 1973. Today Ninesprings is incorporated into Yeovil Country Park.

This photograph, taken in the 1980s, looks down and across to a meadow used by generations of young lads as a football pitch. When the public swimming pool in Huish closed around 1991, this meadow became the site of the new Goldenstones Pools & Leisure Centre with its associated car park, although some of the meadow remains to the east of the car park.

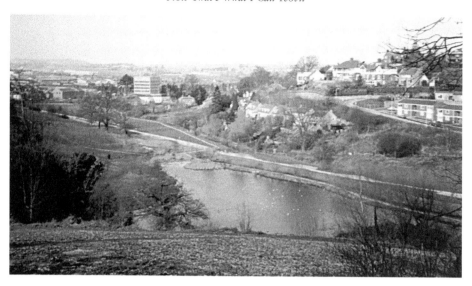

This photograph was taken in 1984 and looks across to Penn Hill, on the right. In the mid-ground is Ninesprings Lake, which, at this time, was relatively undeveloped. On the left is the meadow of the previous photograph on which the Goldenstones Centre was built. The path seen cutting across the photograph was the line of the old Yeovil–Taunton railway that was newly converted into a footpath through the valley to continue as Railway Walk in the next photograph.

Also taken in 1984, this photograph shows the new walk constructed along the line of the old Yeovil Town–Pen Mill railway – hence its name, Railway Walk. Combining with the footpath through the valley seen in the previous photograph, it formed part of a continuous path through the Yeovil Country Park still enjoyed today. This particular section of the walk runs alongside Dodham Brook, on the right, just before it flows into the River Yeo.

One of the remaining green spaces in the very centre of town is St John's Churchyard. It was mainly cleared of tombstones during the 1940s and '50s since when it has acquired the nickname 'The Beach' and is a very convenient place to relax and unwind – especially in the heat of summer, as seen here.

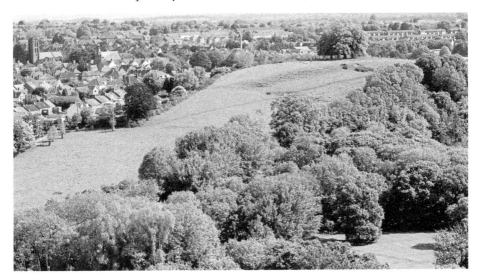

With Yeovil houses nestled along its northern flank, Wyndham Hill is crowned by four lime trees and lies on the immediate southern edge of the town with the River Yeo to its south. It always offers a quiet place to relax as more people tend to visit nearby Summerhouse Hill with its spectacular views. The summit of the hill is recogniseable from many parts of Yeovil and is seen here from the top of Summerhouse Hill, equally close to the town.

ACKNOWLEDGEMENTS

Special thanks to Mike Monk for proofreading not only this book but also my 1,900-plus-page website – www.yeovilhistory.info – which details in much greater depth every photograph subject in this book.

Many photographs in this book are from my collection but I have also been helped enormously by a number of Yeovilians. The author and publisher would like to thank the following people for permission to use copyright material in this book: Rob Baker, Terry Clare, John Cornelius, Roger Froude, Colin Haine, Matthew Harrington, Roger Key, Andy Keyse, Roger McElliott, Chris Rendell, Sonja Skinner, Dave Stone, Jack Sweet, John Williams and Peter Wiltshire. Every attempt has been made to seek permission for copyright material used in this book. However, if we have inadvertently used copyright material without permission / acknowledgement we apologise and we will make the necessary correction at the first opportunity.

ABOUT THE AUTHOR

Local historian Bob Osborn is the author of several books on an eclectic range of subjects including *Yeovil from Old Photographs*, *Carved Medieval Bench Ends of South Somerset*, *Bayonets of the World*, *The Taunton Stop Line* and three works on Italian Futurist Art. After a career in architecture, admin management, web design and management and, latterly, as a learning centre manager and Yeovil College lecturer teaching IT, he is now retired. Bob moved from north London to Yeovil, Somerset, in 1973 and since retiring works almost daily researching and compiling his ever-growing website 'The A-to-Z of Yeovil's History', which currently has over 8,500 images. Bob has four grown-up children and lives in Yeovil with his wife Carolyn and Alice the cat.